Landscape

PHOTOGRAPHY

A GUIDE TO TAKING BETTER PICTURES

Peter Eastway

LONELY PLANET OFFICES

Australia
Head Office
Locked Bag 1, Footscray, Victoria 3011
☎ 03 8379 8000, fax 03 8379 8111
talk2us@lonelyplanet.com.au

UK
72–82 Rosebery Ave,
Clerkenwell, London EC1R 4RW
☎ 020 7841 9000, fax 020 7841 9001
go@lonelyplanet.co.uk

USA
150 Linden St, Oakland, CA 94607
☎ 510 893 8555, toll free 800 275 8555
fax 510 893 8572, info@lonelyplanet.com

Landscape Photography: A Guide to Taking Better Pictures
1st edition May 2005
ISBN 1 70459 669 2

Published by Lonely Planet Publications Pty Ltd
ABN 36 005 607 983

text © Lonely Planet 2005
photographs © Peter Eastway 2005 and photographers as indicated

Cover photograph: Sand dunes, Namibia

 Many of the images in this guide are available for licensing from
Lonely Planet Images: www.lonelyplanetimages.com.

Printed through The Bookmaker International Ltd.
Printed in China

CONTENTS

THE AUTHOR

Peter Eastway is the publisher of *Better Photography* magazine and co-publisher of several other magazines including *Better Digital*, *Better Photoshop Techniques* and *Which Camera – Digital & Film*. *Better Photography* is written for enthusiast photographers on a quarterly basis and has been published for 10 years.

Peter has also edited photographic magazines for other publishers, giving him over 25 years experience in this specialised area. His publications cover all aspects of photography, catering to novices and professionals, and they are highly regarded around the world.

Having worked in most areas of professional photography, Peter's passion is for landscapes. While he still shoots for magazines and editorial clients, and does a little family portraiture, it's landscapes that he loves best. His limited-edition prints are exhibited in selected galleries around Australia and his work can also be seen at www.betterphotography.com.

Peter has won many awards for his photography. In 1996 and 1998 he was the Australian Institute of Professional Photography (AIPP) Australian Professional Photographer of the Year. He was Australian Landscape Photographer of the Year in 1995, 1996 and 1998; NSW Professional Photographer of the Year in 1995, 1996 and 2004; and Australian Illustrative Photographer of the Year in 2004. He is also a Master of Photography, an Honorary Fellow of the AIPP and a founding member of the ACMP (Society of Advertising, Commercial and Magazine Photographers of Australia).

Peter's photography has also appeared in exhibitions and publications in Germany, Japan, New Zealand, UK and the USA. His travels have taken him to many places around the globe, allowing him to pursue his landscape work.

From the Author

I'd always wanted to write a book on landscape photography and it had been sitting on my 'to do' list for several years. So when Lonely Planet's Richard I'Anson rang me, it didn't take me too long to respond to his book proposal with a resounding 'Yes, please!'

The process of writing this book has been a great deal of fun. It has also forced me to put into perspective what I feel about landscape photography. My approach to capturing images has changed dramatically over the years.

In fact, landscape photography itself has changed and matured. Technology has made a big impact on all of us and as I put this book together I realised that it has allowed more people to take better photographs more often. Some of the photographs I was once very proud of didn't make the cut. It wasn't that these photos were poor; rather that the standard we all expect from photographs has improved so much that what was once a good photograph is now just a basic 'record' photograph – a historic document of fact with little feeling or emotion.

I guess this is my underlying message: while the techniques and approaches I outline in the following pages are essential for great photography, capturing a great landscape requires something more. It requires you to be passionate about what you're photographing and to then share that passion with the people who view your photographs.

I hope I can share with you what makes a great landscape photograph and show you how to create your own.

THIS BOOK

From the Publisher

This book was produced in Lonely Planet's Melbourne office. It was commissioned by Laetitia Clapton and series editor Richard I'Anson. Bridget Blair managed the project and Brigitte Barta and Janet Austin edited. The book was designed by Brendan Dempsey and laid out by Steven Cann. James Hardy designed the cover and Ryan Evans, Gerard Walker and Claire Gibson managed pre-press preparation of the photographs.

The Author's Approach

My approach to landscape photography is changing all the time. At present I am not overly interested in reality, so I don't take many 'record shots' – factual photographs with little creativity to commend them. I don't want to end up with a perfect record of a scene or a place unless there is a little twist. That twist can take many forms – it can be a shift in colour, in focus, in angle or in light. Yet while the twist may be created with a photographic technique, it is not the technique itself that I am interested in; rather, it is the effect that technique has on the rendering of my subject.

As you flip through the pages of this book, you will see photographs taken by me over the last 20 years. There are many record shots from my earlier years, but hopefully the subject matter makes them interesting to most people.

Although my approach is now quite different, my starting point has never changed: I have always looked for interesting subject matter, or looked for ways to photograph a seemingly mundane subject in an interesting way.

When I am at a location these days, I am thinking about what I can create rather than just looking at what is there in front of me. What is it that I really like about this place? What can I do to better communicate its atmosphere and my impressions? Like all photographers the first thing I have to do is take the photograph, but rather than just printing it directly out of the camera, I will transfer that image onto my computer so I can interpret it. I will play with the image by changing colour, contrast and brightness. I might add or delete elements, stretch or blur aspects and generally fool around. I have no constraints because I am not creating a historical document for someone to look at in 100 years time; instead I am creating images that come from my imagination.

If you want your friends and family to say 'wow' when they see your landscape photographs, you have to provide them with something more than just a correctly exposed and focused image. Modern cameras take great photographs automatically and in this sense everyone who picks up a camera is a 'photographer'. Your challenge is to produce an image with something more.

My own style of photography has changed from merely recording what I see to pre-visualising what I can create. This change in approach happened around 10 years ago when I read a book by Eddie Ephraums called *Creative Elements*, which showed how he transformed a mundane negative into a wondrous print. I soon realised that having a set of skills in the darkroom would allow me to create much stronger and more emotive images. Knowing how to lighten, darken and tone black-and-white prints enabled me to turn ordinary photographs into images that were more like art.

Having moved from the darkroom to the computer, I am now in the process of a second transformation. Using a digital camera and Photoshop, I have access to all the skills I learned in the darkroom and I can also work in colour.

I hope to encourage you to try to take the record photograph really well and then to consider interpreting it later. I still take lots of record photographs, which I bring home and show my family. However, there are also special images that are really important to me. I might spend several hours, even days working on an image, refining, manipulating and interpreting it until I am happy. Every image is approached differently, though there are some standard techniques that help me work through the post-production process.

As a professional, I have the luxury of an extensive kit of cameras and lenses, but I have honed these down to a small outfit that fits into a single bag for my landscape photography. Currently my camera outfit comprises:

‣ Canon EOS 1Ds Mark II digital SLR (DSLR)
‣ 14mm ultra wide-angle lens
‣ 16-35mm wide-angle zoom
‣ 24mm perspective-control wide-angle lens
‣ 85mm f1.2 mid-telephoto lens
‣ 100-400 telephoto zoom lens
‣ 1.4x converter
‣ Sony laptop computer
‣ Lowepro backpack
‣ Manfrotto carbon-fibre tripod.

I have a range of other lenses that can be swapped around depending on the job, but generally this outfit covers most eventualities. The digital images in this book were captured in RAW mode and converted to 16-bit TIFFs using CaptureOne software. I haven't photographed with film for over two years, but that doesn't mean I won't return to it in the future. Shooting with film is still a valid option and you can always scan your negatives or slides to gain access to digital post-production.

I don't use filters very often, as I prefer to do most of my image adjustments on the computer, but this may change as I find ways to reduce the amount of work I have to do during post-production. Because of the control available in programs like Photoshop and Photoshop Elements, I really have to watch myself because I can spend too much time on images of lesser importance. Time management becomes an important issue with digital photography.

Photo Captions

The photographs and captions in this book are provided to help you learn about taking photographs in a variety of circumstances. Where the information is available, it includes the following details:

‣ camera type and lens
‣ aperture and shutter speed (although most images were taken using aperture-priority mode and so the shutter speed was not recorded)
‣ film type (however, some films are no longer available) or sensor size (measured in pixels)
‣ filters, tripod and flash, if used.

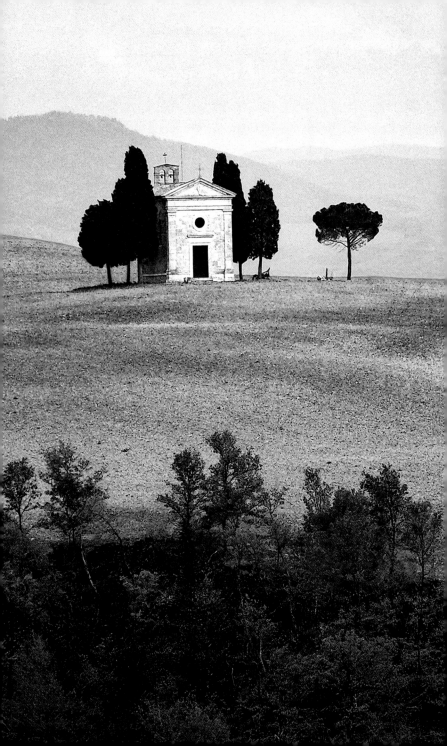

INTRODUCTION

The challenge of landscape photography is to create images that will make your friends, family and other viewers gasp with excitement and perhaps even spontaneously buy a plane ticket to visit the destination themselves.

A great landscape photograph will have drama, impact or presence. Its strength may come from the subject itself, the angle it's shot from, the time of day or the weather conditions. However, you'll find the very best ones have a few aspects in common:

▸ Inspiring subject matter. Most great landscape photographs are of interesting and unusual landscapes. You may need to make an extra effort to get to these locations, but it will be worth it.

▸ Superb framing. In great photos, the compositional elements are 'balanced' within the frame; there are no unwanted elements distracting the viewer, and there is a flow from one element to the next. Importantly, the horizon is straight and you won't find half a tree or a rubbish bin chopped off on one side.

▸ Exquisite lighting. Some landscapes look great in all lighting, while others require a particular time of day or season to look their best. In a great landscape photograph the lighting highlights the subject and reveals detail and texture.

▸ Invisible photographic technique. Great landscape photographs let the viewer concentrate on the subject without being distracted by poor image quality or incorrect exposure.

▸ Clear communication. A great landscape image clearly communicates the photographer's vision of the landscape. To convey the power of a pristine landscape, for instance, the photographer would probably exclude any trace of human presence such as fences or roads; conversely, if the photographer intends to show the hand of man in a rural landscape, then ploughed fields and farm buildings would be included in the composition.

Great landscape photography can be captured in black and white or colour. The late Ansel Adams is one of the world's best-known landscape photographers and his images – startling in their clarity and composition – are all in glorious black and white. However, many famous landscape photographs were taken before colour film was commercially available and even Ansel Adams in his later years said he was really enjoying capturing landscapes in colour.

Some landscapes work well in colour, while others look terrific in black and white. The host of options in between, such as sepia-toned (light brown) images and hand-coloured prints (where paints or pastels are applied directly to a black-and-white photo), are also worth trying. What works for one photographer may not work for another, because it all comes back to what you, the photographer, want to say about the landscape.

Cappella di Vitaleta, San Quirico d'Orcia, Italy
◀ DSLR, 100-400mm lens at 400mm, f8, ISO 800, 4072 x 2708, RAW, tripod

LANDSCAPES IN COLOUR

Colour landscape photographs can certainly re-create reality very well. Modern films and digital sensors can produce enhanced, saturated colours that remind us of what we experienced at a particular location. In many ways the colours are not accurate to reality, but they are accurate to our memory of reality.

If your objective is to produce a strong photograph that makes people look a second time, then colour can be an important factor. To produce a colour photograph that has as much impact as black and white, you need to consider carefully the colours you are including. By simply zooming in on a scene and eliminating distracting areas of colour surrounding the subject, you can minimise the number of different colours in a photograph. Since we're used to seeing a full range of colours in most photographs, an image with a smaller range of hues can seem different and exciting.

We can also choose the type of light that illuminates a landscape, and this light in turn affects the nature of the colours. If we photograph a landscape during the middle of the day, the colours in some landscapes will appear washed out and flat, while late-afternoon light will probably produce warmer, more attractive colours. On the other hand, to capture the sparkling blues and greens in some coastal scenes, midday lighting and a polarising filter work brilliantly.

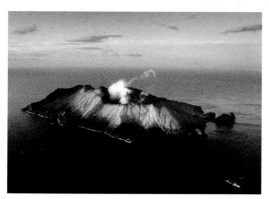

White Island, New Zealand

Shot from a helicopter, the White Island volcano was relatively quiet on this afternoon. The use of black-and-white film and advanced darkroom techniques (copper toning on the edges of the volcano's cone) produce a unique looking image.

◀ 35mm SLR, 28-135mm lens, f5.6, Tri-X

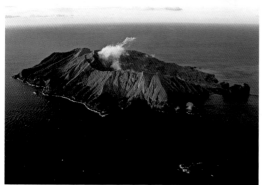

White Island, New Zealand

A similar photo was taken with a second camera loaded with colour film. While the angle of view is striking, the colour is a little flat and this photo does not have nearly as much impact and drama as the black-and-white version.

◀ 35mm SLR, 28-135mm lens, f5.6, Astia

LANDSCAPES IN BLACK & WHITE

Many professionals now shoot their black-and-white photos with a digital camera and use image-editing software to refine their images, though the purists will keep shooting film until they depart for that great darkroom in the sky.

However you capture black-and-white images, it pays to spend a little time reading and viewing books on black-and-white photography. Black-and-white has great power, probably because it is different from what we see in real life. Because a black-and-white photo has no colour information, the viewer is required to focus on shape and form. Light becomes a really important ingredient, as it reveals shape, form and texture in your subject.

The colour of your subject is important, not because the colours will appear in your final image but because when colours are converted to black and white, different grey tones will result. If you end up with very similar tones of grey, the shape and form of the subject will be hidden.

Expert black-and-white photographers use colour filters to control the way colours are converted into black and white. Favourite filters are yellow, orange and red which are used to darken blue skies – blue light from the sky is not transmitted by these filters, so less light reaches the film and the resulting image is darker. Further enhancements can be made in the darkroom, by darkening and lightening certain areas. Digital photographers don't need to use colour filters at the time they capture the image, as they can achieve similar results on the computer. See Digital Post-Production in Part Five for details.

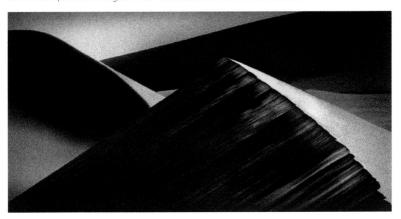

Sand dune, Sesrium, Namibia

In the middle of the day the sun was effectively producing a side light on the crests of these dunes. A red filter was applied to greatly increase the contrast, and in the darkroom the edges of the dunes were lightened using bleach and a small paintbrush.

▲ 35mm SLR, 75-300mm lens at 300mm, f22, T-Max 100, red filter, tripod

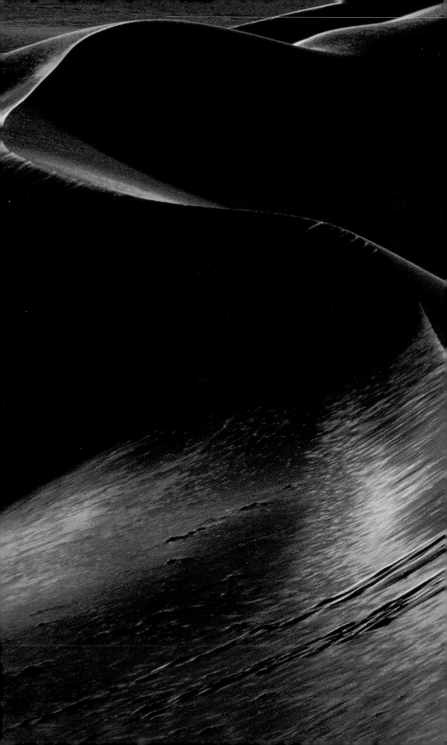

PART ONE:

Some photographers seem to have all the luck. They're always in the right place at the right time, camera in hand. However, it isn't just a matter of luck. It's also about planning and being prepared, and then increasing your chances by always having a camera with you. Photographing landscapes will be more enjoyable and successful if you spend a little time before your trip preparing your equipment, researching your destinations and planning your itinerary. You mightn't be able to control everything, but you'll be better prepared for the weather conditions and better able to prioritise your time so that your chances of taking good photos are maximised.

BEFORE YOU SHOOT

Sand dune, Sesrium, Namibia
◄ 35mm SLR, 300mm lens, f16, Velvia, tripod

EQUIPMENT

A poor artist should never blame his or her tools, but there's no doubt the right camera and equipment can help you take better landscape photographs. You may have already purchased a camera and it can certainly be pressed into service, no matter its type. However, there is a range of accessories and other equipment that can make the landscape photographer's life a better one.

More equipment doesn't automatically mean better landscape photographs. Build up your kit of accessories slowly and sensibly, being mindful that everything you add to your camera bag also has to be carried – a heavy camera bag is the best way to ruin your photography expeditions.

It's best to keep your camera equipment relatively simple. Usually one camera (with several lenses) and one film type will see you through.

CAMERAS

With advances in film and digital technology, most cameras can be used to capture great landscapes. The technical requirements don't need to be particularly demanding, although image size and lens quality are issues for those wanting superlative results.

Put simply, for landscape photography a camera needs to provide a high-quality image. When people look at landscape photos, they like to see lots of detail, from the pebbles on the ground and the leaves in the trees to the subtle tones of the sky and clouds.

Specialist landscape photographers use specialist equipment that produces exceptionally clear and detailed images, but for everyone else the best camera to capture landscapes is a 35mm film or digital single lens reflex camera.

Film or Digital?

Most new cameras sold today are digital, and film is quickly becoming a medium of the past. In some ways, it's a great pity that digital is taking over because the quality of modern films is just so good. When digital cameras first arrived, they couldn't match the quality of film, but this has all changed. With the exception of camera phones, any good digital camera with a 5 MP sensor (or larger) and a good lens can be used to produce postcard-size photographs that are indistinguishable from film. The same cameras can produce beautiful A4 enlargements that only experts can tell apart from film. For amateur and enthusiast photographers, it is a digital future.

The main reason for continuing to shoot with film is if you're making poster-size enlargements, in which case film is better than an 'affordable' digital camera. (If money is no object, then already today you can purchase professional digital camera systems that surpass the quality of any film – a bold statement, but true!)

Many professionals will continue to shoot film for some time to come. This is because they already use expensive large- and medium-format cameras which use large sheets of film (up to 8 x 10in or 20 x 25cm in some cases) and the quality is simply breathtaking. To produce this quality with digital is possible, but other issues such as portability and cost come into play.

Also, there are some locations in the world where digital cameras may not perform as reliably as film-based cameras. Already many professional landscape photographers use manual film cameras instead of electronic ones because of climatic conditions. The cold of Antarctica, the heat of the desert and the humidity of the tropics can play havoc with electronic cameras, so it's likely film cameras will continue to be favoured for these specific tasks.

Most readers with an interest in landscape photography will probably be using 35mm single lens reflex (SLR) cameras or their digital equivalent (DSLR) – and these are our recommendations – but most camera types can be used to capture great landscapes. If you've purchased a good-quality digital camera, whether a DSLR or a compact, you can effectively match the quality of 35mm film as long as it has a 5 MP sensor or greater.

DIGITAL FILE FORMATS

The data captured by a camera to create a digital image is stored in a file format so that it can be retrieved and processed using photo-editing software. There are many file-format options but the most commonly used in digital image capture are TIFF (Tagged Image File Format), JPEG (Joint Photographic Experts Group) and RAW.

TIFF is an industry-standard file format commonly used for storing images intended for print publishing. Some advanced compacts and DSLR cameras offer TIFF storage as the highest-quality option. TIFF files are usually uncompressed and can be subjected to extensive post-capture processing. They quickly use up space on a memory card and take longer to be saved.

Most digital cameras utilise the industry-standard JPEG file format and compression routine. JPEG files are compressed using lossy compression that offers quick in-camera processing and allows larger numbers of images to be stored on memory cards. Most entry-level compacts only provide one 'resolution' or 'quality' setting. Better quality models provide separate 'resolution' and 'quality' settings; 'resolution' adjusts the size of the pixel array, while 'quality' sets the level of JPEG compression. The degree of compression can be varied through a camera control or menu option usually labelled 'Image Quality'. This option allows images to be stored in a range of file sizes or compression levels usually described as Low, Medium and High. The greater the compression, the lower the quality of the image file.

If you want to get the absolute best results from your digital camera, capture your images using the RAW file format, an option available on some compact and all DSLR cameras. Often described as a digital negative, it's the format preferred by professional photographers. RAW files are not processed by the camera's software, which can compress the data and make adjustments that are embedded irremovably in the image file. Instead, RAW files are compressed using a lossless process, so they retain all the information originally captured but are saved to the memory card quickly. Adjustments such as contrast, saturation, sharpness and white balance are made by the photographer after the image has been downloaded to a computer. Creative decisions can then be tailored to each image using the much greater functionality of image-editing software.

Shooting RAW files requires a considerable amount of post-capture computer time and more than a basic understanding of image-editing software. Cameras with RAW file capture are sold with proprietary software for that purpose, or you can use software like Adobe® Photoshop® and Photoshop® Elements. Your investment in time and equipment will be rewarded with digital files and prints that maximise the capabilities of your camera.

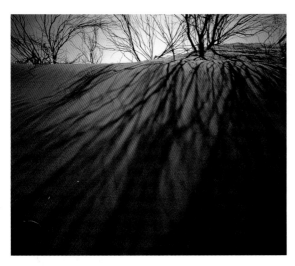

**Scrub Shadows,
Yulara, Australia**

Although shot with the
ultimate film camera, these
days digital cameras are
every bit as good for smaller
size prints.

◄ 4x5 inch large format camera,
90mm lens, f16, Velvia, tripod

If you're happy with prints up to A3 in size, then a 5 MP sensor will produce quality that, to the naked eye, can match that of film.

The major advantage that digital photography has when compared to film photography is its instant feedback. Using the camera's preview screen, you can check your composition and exposure. If things are not to your liking, you can take another frame, or two or three. In fact, you can continue shooting the landscape until you get it right, and there is no costly film and processing to worry about.

Single Lens Reflex Cameras – Digital & Film

The SLR or DSLR is the ultimate picture-taking machine. Not only is it ideal for landscape photography, it's fantastic for practically every other type of photography as well. The SLR is named after the shutter-and-mirror arrangement in the camera. A mirror reflects the image from the lens up into the viewfinder, but the instant you press the shutter release button, the mirror flips up out of the way and the shutter opens to expose the film. The mirror returns to its original position and you're ready to take another photo.

The advantage of this design is that photographers are able to frame their subject precisely. Most other small cameras use two lenses – one to take the photo and the other for the viewfinder. There is always a small parallax error with this set-up, more so with closer subjects than landscapes. The SLR eliminates this problem.

Another advantage is focusing. If the image is out of focus, you see this immediately through the viewfinder of an SLR, but with other camera designs you might not know there's a problem until the film is processed.

Perhaps the most significant advantage of the SLR design is its huge range of accessories, especially lenses. While other camera designs can use interchangeable lenses, they can't offer the range of focal lengths (from wide-angle to telephoto) that the SLR can handle. The SLR is the most versatile camera format and for this reason alone, it is ideal for landscape photography.

Compact Film Cameras

Compact cameras are small and pocketable. They take the same 35mm film as SLR cameras and usually have a zoom lens. Most have a range of useful features that are designed for family and travel photography, and which can also be used for landscape photography.

There's no problem with using a compact for landscapes, but there are some limitations. For instance, compact cameras don't have interchangeable lenses, so you won't be able to use ultra wide-angle or super telephoto lenses. And on some compact cameras there are no manual controls, so you won't be able to set the aperture or shutter speed for special effects. Neither of these shortcomings are terminal – you'll still be able to shoot good landscape photos, but if you're serious about your landscapes, you'll probably want to trade up to an SLR camera.

The auto-focus system on compact cameras is different from the system found on SLR cameras. If you're taking landscape photos out of a bus or train window, for example, the sheet of glass (the window) between you and your subject (the landscape) can fool the camera into thinking everything is a lot closer than it really is (the camera tries to focus on the glass, not the landscape). Some cameras have a special 'landscape' button which sets the focus to infinity, and this will usually produce a good, clear landscape photograph through a window.

Compact Digital Cameras

Compact digital cameras are aimed at the same market as compact film cameras. They are small and easy to carry, making them ideal travel cameras.

Lower-resolution digital cameras are not suitable for landscape work, as a minimum 5 MP sensor is recommended. Sensors 5 MP or larger will be able to produce high-quality images up to A3 in size, approaching or equivalent in quality to film.

Like compact film cameras, there are no interchangeable lenses available for compact digital cameras, but you may be able to purchase converter lenses to produce a wider or more telephoto effect.

Similarly, you need to check that your compact digital camera allows you to manually set the aperture or shutter speed – not all models will give you this control, though some of the more advanced ones will give you complete control and are very like an SLR camera in their operation.

Professional Formats

If a good landscape photo requires lots of detail, then the best landscape photos will be taken with cameras that produce the most detail. There are three types that professionals use.

Medium-Format Cameras

A medium-format camera is physically larger and heavier than a 35mm camera, mainly because it takes film that is larger than 35mm. Medium-format film (also called roll film or 120 film) is 6cm high. Its width ranges from 4.5cm to 17cm, depending on the type of camera.

Medium-format film is capable of capturing the finest detail and nuances of colour and tone, and, because it's a larger size, medium-format negatives and transparencies don't require as much enlargement. If you enlarge a 35mm negative too much, the image breaks

up and the grain becomes intrusive. With medium-format negatives, your enlargements have to be really big before this becomes an issue.

The most common medium-format sizes are 6 x 4.5cm, 6 x 6cm, 6 x 7cm and 6 x 9cm. Many of these cameras are very heavy and designed for studio photography, but if you're prepared to carry them around (as many professionals do), they certainly produce the goods for landscapes.

The lightweight rangefinder models (such as the Mamiya 7II and Bronica RF) are better options for landscape photography when you're hiking out to your location. The rangefinder camera is named after its focusing system. In simple terms, a rangefinder uses two lenses: one for focusing and another for exposing the film. In an SLR, a mirror arrangement allows the camera to use one lens for both procedures. It's a lot easier to build a lightweight rangefinder than an SLR, hence their popularity with photographers on the move.

Panoramic Cameras

Panoramic cameras also use medium-format film, but the image size is 6 x 12cm or 6 x 17cm. Only a few models of panoramic cameras are manufactured today, and the most popular is made by Linhof.

Panoramic cameras are large, heavy and completely manual. With the 6 x 17cm size, you get four shots on a roll of 120 film (eight shots on 220 film) and the quality is more than breathtaking.

The advantage of a panoramic camera is that you don't waste valuable film on unwanted foreground and sky – the format of the film is ideal for landscapes.

Large-Format Cameras

Large-format cameras (also called view cameras) don't use roll film. Instead, single sheets of film (4 x 5in or 8 x 10in) are inserted one at a time. Camera operation is completely manual, and the design of the camera allows professionals and advanced enthusiasts extensive control over image sharpness and perspective.

LENSES

There is no single lens that is best for landscape photography. Every lens from an ultra wide-angle to a super telephoto can be useful, so the standard lens that came with your camera will certainly do the job.

However, as more experience is gained, many landscape photographers find themselves wanting lenses beyond their standard lens, gravitating towards wider or more telephoto angles. The wider the range of lenses you own, the more opportunities you will have for taking top-notch landscape photographs (but don't collect so many lenses that you spend all your time deciding which one to use).

Not all lenses are manufactured equally. Some lenses are produced to a budget and so while the price is right, the quality can be average. On the other hand, the really expensive lenses usually have superlative performance.

Lens quality is relevant to the size of the prints you're making. If you're only producing postcard-size prints, then the budget lenses are adequate. Prints up to A4 size should also

look pretty good – and if you never compare the quality your lens produces with that of a superior lens, you need never worry! On the other hand, if you're fussy and discerning when it comes to image quality, spend the extra money needed to get the better-quality lenses.

Most lenses perform best at certain apertures. As a rule of thumb, it's best to close your lens down two to three stops from its maximum aperture to get the maximum clarity. For instance, if your lens has a maximum aperture of f3.5-4.5, use an aperture of f8 or f11 for the sharpest result. Of course, this technique only produces the sharpest result on the area of the image that is in sharp focus. There are other reasons why you might choose to use a different aperture, such as to control depth of field, so you can't always set the lens at its sharpest setting. The quality difference isn't so marked with top-quality lenses – quality is high at all settings – and so setting the optimum aperture isn't so critical. Hence, it's better to have a quality lens that produces good results at all apertures, rather than a budget lens that only performs well at one or two apertures.

FILTERS

A handful of filters is one of the best tricks in the landscape photographer's gadget bag.

Filters simply screw into the front of the lens or are placed in front of the lens via a screw-in adapter. Screw-in filters are the cheapest if you're only buying one filter and you only have one lens. If you have more than one lens and each lens has a different filter-thread diameter, then you'll need a filter of each size for each lens. In this situation, a filter holder with adapters for each lens (such as the popular Cokin system of square and rectangular filters) is a more economical option. You only need to buy one of each filter and swap it from lens to lens as the need arises.

Ultraviolet Filters
The most common filter (and one that the camera salesperson will often suggest you buy with your lens) is the ultraviolet (UV) filter. The blue colour you see in the distance in land-scape photos is generally produced by ultraviolet light. The UV filter's job is to remove the ultraviolet light, reducing the blue colouration and creating a clearer image. It also helps you look through the haze.

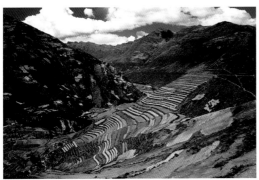

Inca Sacred Valley, Peru

The combination of clear air and an ultraviolet filter over the lens have produced an image with remarkable clarity in the distance.

◀ 35mm SLR, 180mm lens, 1/125 f2.8, Kodachrome 200 rated at ISO 400 (one stop push)

An alternative to the UV filter is the Skylight 1A filter, which has a similar effect.

These filters are often left on the front of lenses as protective devices. It's much cheaper to replace a scratched filter than to repair a scratched lens.

However, neither of these filters is going to make your landscape photographs significantly better.

Polarising Filters

A polarising filter is generally used to produce deep, rich blue skies. Unlike most filters, which sit in a fixed position, a polarising filter is rotated by the photographer. As the filter rotates, the polarising effect increases and then decreases – looking through the lens, you simply turn the filter until you like the effect.

With a polarising filter blue skies look great and even better when there are some white fluffy clouds to provide contrast. However, if you're using a really wide-angle lens (around 24mm or wider), the polarising effect may not stretch across the image frame and you could end up with an unattractive, two-tone sky.

A polarising filter can be used to increase colour saturation in many different areas. Green foliage and even red roof tiles can look extremely vibrant. The only downside of the polarising filter is it can increase contrast in the image, which means your shadows can fill in and hide important detail.

Try using the polarising filter on pools of water and rivers. In one position, the polarising filter will let you look beneath the water surface; turn the filter around and the view below will disappear to be replaced by what is being reflected off the water's surface. It's a great filter to use when you have a lake or river in your foreground.

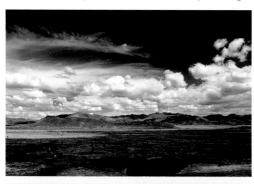

Alpine plain, near Puno, Peru

At high altitudes, the sky takes on a darker hue and with a polarising filter this hue can almost become black. Note how clear the air is at altitude.

◀ 35mm SLR, 28-235mm lens, f5.6, Kodachrome

USING A POLARISING FILTER WITH A COMPACT CAMERA

Polarising filters are easy to use with an SLR camera because the viewfinder looks through the same lens that takes the photo. With a compact camera, the viewfinder lens is separate to the picture-taking lens, so when you attach a polarising filter, the viewfinder probably won't show the effect.

There are two solutions. The first is to use a large polarising filter and hand-hold it over both lenses. The second is to simply hold the filter up to your eye, rotate it until it produces the most pleasing effect, and then carefully position it in front of your camera lens in the same position. Both solutions are a little cumbersome but very workable.

Warming Filters

Another important filter used by landscape photographers is a warming filter, which is amber (yellow/orange) in colour and gives a landscape a subtle warming effect, similar to the light cast by a setting sun.

Warming filters come in various strengths – 81A, 81B, 81C, 81D and 81EF – with the latter being the strongest. Many photographers keep an 81A or 81B permanently attached to their lens, instead of a UV or Skylight 1A filter.

Warming filters are best used in sunny conditions. When used under overcast light they can sometimes produce a murky result. If you're looking for a little extra colour in your images on an overcast day, you're better off using a highly saturated colour film rather than a warming filter.

Warming filters are often used in combination with other filters such as polarisers, graduated filters and indeed other warming filters (to create a stronger effect). There's no right or wrong combination – just don't overdo it!

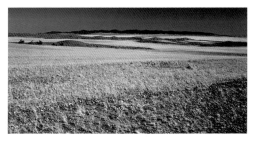

Grasslands, east of Namib-Naukluft Park, Namibia

Both a polarising filter and a warming filter have been used here, enhancing the warm tones in the foreground and the depth of colour in the sky.

◀ 35mm SLR, 28-135mm lens, f5.6, Ektachrome 100

Graduated Neutral Density Filters

One of the biggest problems with landscape photography is matching the exposure of the sky with that of the land. The sky is invariably lighter (brighter) than the land below and film has trouble recording both areas at the same time. As a result the sky will look washed out but the landscape will look correct, or the landscape will look dark and muddy but the sky will be pretty as a picture.

The solution is to reduce the amount of light from the sky by placing a filter over it.

A neutral density (ND) filter reduces the amount of light that reaches the film, but without affecting the colour or contrast of the image. A graduated neutral density filter is a two-

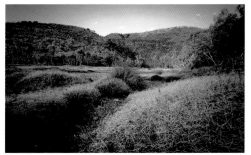

Canyon mouth, MacDonnell Ranges, Australia

As the sun was setting, both the sky and the rock wall in the distance were strongly illuminated, while the foliage in the foreground lay in shadow. A graduated ND filter (0.6, which is equivalent to two stops) was placed over the bright area to balance the exposures.

◀ 4 x 5in large-format camera, 65mm lens, f32, Velvia, tripod

tone filter. One half of the filter is completely clear, while the other is a neutral density filter and there is a graduated area in between.

In a typical landscape, the gradation in the filter is placed along the horizon line. Graduated neutral density filters are best purchased as rectangular filters in a holder so you can slide the filter up and down, depending on where you are positioning the horizon. (You don't need the filter holder – you can just hold the filter in front of the lens with your free hand.)

Graduated neutral density filters come in different strengths, usually 0.3, 0.6 and 0.9. If only purchasing one, try the 0.6.

Depending on the design of your filter holder (and how far it holds the filters from the lens), there can be problems with graduated filters when using very small apertures. Due to the increased depth of field at small apertures, the gradation area can appear obvious within the photograph, and the problem is worse with ultra wide-angles. When you first purchase one of these filters, shoot some frames and test the effect with different lenses at different aperture settings. This will reveal any limitations in the filter system you have purchased.

Coloured Graduated Filters

There is a host of colour graduated filters as well. While they can also even up the exposure difference between sky and land, they are generally used to add colour. One of the most

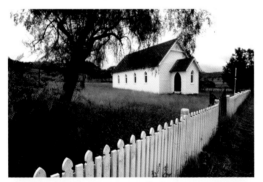

popular colours is tobacco, which can add a little sunset colour to a dull, overcast sky.

The idea behind traditional landscape photography is to re-create what nature has provided, so coloured graduated filters are not always looked upon kindly! However, there's no reason why you can't try a few colour graduated filters to

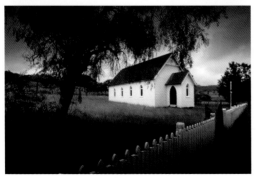

**Country church,
Willow Tree, Australia**

Here is the same subject photographed without filters (top) and with two graduated filters (bottom). A strong orange graduated filter has been added to the sky, while a graduated neutral density filter was added along the fence, leaving just the middle area unfiltered.

◀ 35mm SLR, 28mm lens, f16, Velvia, tripod

help you out in difficult lighting situations, but try more subtle colours rather than the strong or fluoro colours.

If you're wanting to be subtle, a graduated filter with warm pinks and oranges is best used either early in the morning or late in the day when we would expect to see this colouration; if used in the middle of the day the effect of these colours can look unnatural and you might be better served with a blue filter.

Full-Colour Filters

The full-colour filters, such as yellow, orange, red, blue and green, are designed only for black-and-white photography. These filters affect how light or dark the greys are in the black-and-white photo, giving landscape photographers more control over the image.

For instance, in black-and-white photos the sky generally records as a very pale grey or white (because it is so much brighter than the landscape below). However, by reducing the amount of blue light reaching the film, the sky can be darkened. A yellow filter reduces some blue, while a red filter reduces most of the blue and hence creates a very dark grey or almost black sky. The red filter works well with fluffy white clouds and a deep blue sky.

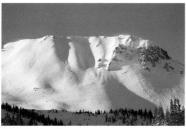

Original colour image

**Winter,
Mammoth Mountain, USA**

Colour images recorded in black and white often produce washed-out skies. If the original colours are strong (as in the sky shown here), colour filters can make dramatic changes to the way the scene is rendered in black and white.

◀ DSLR, 100-400mm lens, f5.6, ISO 100, 4072 x 2708, RAW

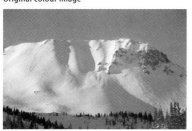

B&W, no filter

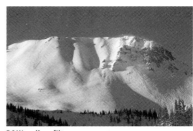

B&W, yellow filter

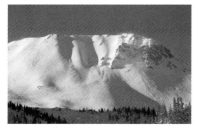

B&W, orange filter

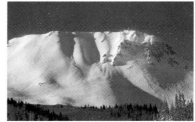

B&W, red filter

TRIPODS & CABLE RELEASES

No matter what type of camera you're going to use for landscape photography, a tripod is indispensable.

While it's true many great landscape photos have been taken without a tripod, the best ones invariably resulted from a three-legged support of some kind.

Most good landscape photographs rely on fine detail and texture, so the image needs to be sharp and clear. One of the easiest ways to ruin the sharpness and clarity available from your camera system is to move the camera slightly during exposure. This is called camera shake.

Camera shake is present in all hand-held photos – it's just a matter of degree. To avoid camera shake, you can use a fast shutter speed, but even so, some camera shake will be present. For travel, family and portrait photography, an almost invisible amount of camera shake will not be an issue, but for a beautiful landscape photo where you want your viewers to feel as though they can walk into your picture, every little bit of detail is important. A tripod used properly will eliminate quality-destroying camera shake.

A tripod also enables you to shoot in low light, twilight and at night. Exposure times of several seconds or even several hours can be required and the only way of keeping the camera still is with a tripod.

When travelling, the weight and bulk of a tripod might be a problem, but even a very lightweight or flimsy tripod is better than no tripod at all, unless you are photographing strong winds or other difficult circumstances.

Some manufacturers make carbon-fibre tripods which are up to 30% lighter than ordinary aluminium models. While a tad expensive, they make travelling with a tripod much more pleasurable.

While thinking tripods, think about a cable release as well. Even with your camera sitting securely on a tripod, you can still jar the camera when pressing the shutter button. The solution is to use a cable release. Manual cameras generally use manual cable releases, while electronic cameras (film and digital) generally use electronic releases. The length of cable allows you to trip the shutter release without bumping the camera, ensuring no camera shake.

Not all the photos reproduced in this book used a tripod or a cable release, but many images wouldn't have turned out without them.

CAMERA BAGS

As a landscape photographer you are generally on the move, so it's important to have a camera bag that will move with you. In general, a backpack design is best because it allows you to walk and work with your cameras securely on your back, while keeping both hands free to hold and operate your camera or climb a steep hill.

However, if you have a lot of equipment or a bad back, you'll need to look for alternatives.

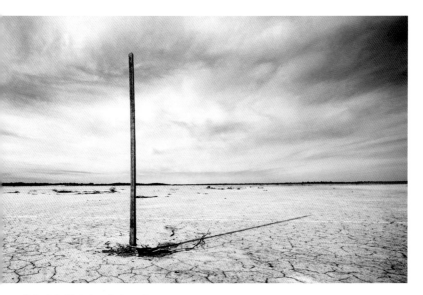

Stake, Lake Yindarlgooda, Australia

Are tripods absolutely essential? Yes, but as it turns out, this photo was taken without one. To achieve the low angle, I lay down on the ground and supported the camera with my forehead and elbows to keep the cameras as steady as possible. (And it worked because the editor thought I'd used a tripod!)

▲ DSLR, 14mm lens, f22, 4072 x 2708, RAW

The best option is a porter to carry your equipment for you. Otherwise, buy very light equipment and take as little as possible.

A number of companies (such as Lowepro) make backpacks specifically for photographers. These backpacks are well designed to hold cameras, lenses and even computers; they are made of water-resistant material to handle inclement weather, and are ergonomically designed for comfort. They really are very sophisticated pieces of equipment.

Some photographers are inclined to buy the biggest backpack, but chances are it will be too heavy to carry if you fill it up with camera gear. While you might be able to lift it in your living room at home, carrying it for eight hours on your back while on safari is a completely different matter. A heavy backpack can ruin your trip and your photography.

The smaller backpacks are the most sensible option because they will force you to limit the amount of equipment you carry. Some professional photographers take a lot of equipment packed in heavy plastic or metal trunks and padlock these in their hotel rooms. They then decant the equipment they need for the day into a lighter bag – often a backpack.

If you're not into a backpack-style bag, look at a soft-sided camera bag, not one with hard edges that will bruise your sides by the end of the day. Again, don't buy too big a bag and don't buy one that says, 'cameras inside: please steal me'.

If your landscape photography involves overseas travel, you will probably wish to live with your camera bag 24/7, so keep this in mind when you make a purchase!

FILM & SENSORS

If shooting film, you need to make a few decisions about the type of film you wish to work with – prints or slides, colour or black and white, fine grain or grainy. And while digital cameras don't require as many up-front decisions, it's good to understand ahead of time what your camera is capable of.

BLACK & WHITE PRINTS

If you're just starting out with black and white, a fine-grain ISO 100 film such as Kodak's T-Max 100 is recommended. The ISO 100 films will provide you with excellent tonal separation as well as fine grain (when processed properly).

For photographers without access to a darkroom, Kodak and Ilford manufacture black-and-white films that can be processed using standard colour chemistry (Ilford XP2 Super, Kodak BW400CN, Kodak Black & White), which means your local colour lab can process them for you. However, if your local lab prints them onto colour paper (as is intended by the manufacturers), you're not going to end up with a print with the same deep blacks and brilliant whites that can be produced by dedicated black-and-white materials. The results are still very good, but a little softer in contrast. It's certainly worth testing a roll or two before you travel to see if they give you the results you're after.

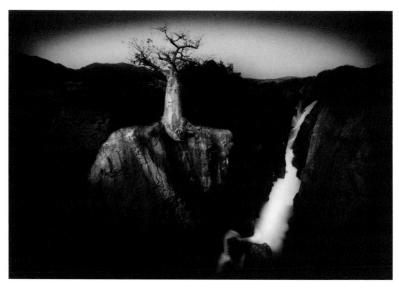

Epupa Falls, Angola.

Black and white photography can be very powerful, as it concentrates the viewer's attention on shape and form without the distraction of colour. Furthermore, darkroom and/or digital skills can be used to subtly enhance the image. In this case, the tree and its supporting rock have been lightened and toned in the darkroom.

▲ 35mm SLR, 14mm lens, f11, APX 100, tripod.

If you have your own black-and-white darkroom, you've probably already settled on a favourite film and developer combination for your general photography. There's no reason to change it just because you're shooting landscapes, though if you wanted a finer grain or a longer tonal range, you could experiment with different film, developer and development combinations.

COLOUR TRANSPARENCIES

Many professional photographers shoot with colour transparency (slide) film for a number of technical reasons. First, colour transparency film is generally sharper and clearer than colour negative. Second, it generally has better colour saturation. Third, after processing, the colour and exposure in the transparency are fixed, whereas if you hand over a negative to someone, you have no control over how the final print ends up. And fourth, in the past the print and publishing industries were set up to scan transparencies, not prints. These days, none of these issues is insurmountable, though transparency film is still a good idea if you plan to send your photos to publications or slide libraries.

Fujichrome Velvia 50 is the colour transparency film favoured by many landscape photographers. It's popular because of its very fine grain and its beautifully rich colour palette. Although it is rated at ISO 50, it is generally better exposed at ISO 32 or ISO 40 , otherwise photos can look a little dark and underexposed. Though Fujichrome Velvia 100 is a little faster, film speed isn't such a big issue for landscape photography because normally a tripod

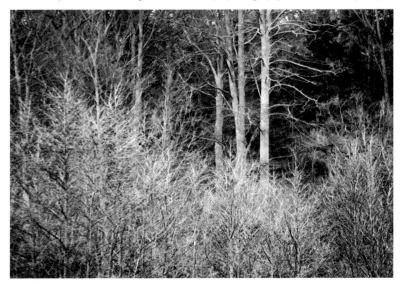

Winter forest, Salzburg, Austria
I used slide film to capture these trees because at the time I loved returning home and creating slide shows. Today I would shoot the same scene on either colour negative film or digitally, and create the slide show on the computer.

▲ 35mm SLR, 100-200mm lens at 200mm, f8, Kodachrome

is used and fast shutter speeds are not essential. Fujichrome Velvia 50 has higher colour saturation (assuming this is what you want), though the ISO 100 version is slightly sharper.

The main issue with these two emulsions is their price. In many countries, professional films cost up to double the price of consumer films. If the price is a problem for you, try a roll of Fujichrome Sensia 100, Kodak Elite Chrome 100 or Kodak Elite Chrome Extra Color 100. While cheaper, these films are not inferior in quality. The reason professional films cost more has to do with the way they are manufactured and stored until sale, not the end result. Unfortunately, if you want the colour palette Fujichrome Velvia offers, there is no consumer film equivalent because it is only available as a professional film.

COLOUR PRINTS

If you want to create a photo album and perhaps hang one or two of your best images on the wall, colour negative film is best.

While it's true you can produce prints from slides (and the quality can be even better than prints from negatives), this procedure is generally more expensive than making prints from negatives. This is changing somewhat with digital technology because some labs simply scan your slides and output digital prints – as far as the scanning process is concerned, it doesn't matter whether it's a negative or a transparency. All up, though, it could cost more than twice as much as shooting with colour negative film.

There is also a wide range of colour negative films to choose from, some with sensational richness and vibrancy, others designed with skin tones and portraiture in mind. For landscape photographs, you'll probably prefer a high-saturation film.

The best colour negative (print) films to try are Kodak High Definition, Fujicolor Superia Real and Fujicolor Reala 100. The latter film has a more neutral colour palette compared to Superia, but still has beautiful colour saturation and depth.

FILM SPEED

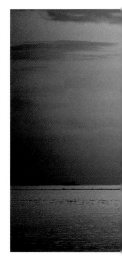

All film is light sensitive. The measurement of sensitivity is expressed in the International Standards Organisation (ISO) rating, which generally ranges from ISO 25 to ISO 3200. The more sensitive a film is to light, the higher its ISO rating or film speed.

Slow films have a rating of ISO 25 to 50, although film sensitivity of 25 ISO is considered to be too 'slow' by most photographers, as long exposures are required to accumulate sufficient light for a correct exposure. Films that are ISO 100 to 200 are considered medium-speed, while ISO 400 is fast and ISO 800 to 3200 is really fast.

Evening voyage, Padang harbour, Sumatra

There's generally not much movement in landscape photography, so fast sensors, fast films and fast shutter speeds aren't essential. However, if there is movement, be sure to keep an eye on your shutter speed – and in turn the sensitivity setting of the digital sensor.

▶ DSLR, 300mm lens, 1/2000 f2.8, ISO 100, 4072 x 2708, RAW

Slow films generally have a finer grain than fast films. If you're looking for lots of clarity and detail in your landscapes, then a fine-grain film is best. Grain is the structure of the film, which is barely visible when you look at a print or transparency. It looks a bit like grains of sand. If the grain is too large, it can interfere with the image and so it is harder to see the subject detail in the landscape. The finer the grain of the film, the better the clarity of the resulting images.

Generally, faster films are useful when hand-holding the camera or when working in low-light conditions without a tripod. However, if you're carrying a tripod, then the very fine grain ISO 50 and ISO 100 films are best for landscape photography.

SENSOR SENSITIVITY

When it comes to digital cameras, the sensitivity of the image sensor is given an equivalent measurement and ISO 100 is considered standard. Some digital cameras allow you to change the sensitivity of the sensor. This can be really useful if you need to shoot in low light and you don't have a tripod. Unfortunately, when you increase the sensitivity on a digital camera, the consequence is 'noise' in the image. Noise can be compared to grain in film. It's generally seen in digital photos as spots of red, green, white or black. The more spots there are, the harder it is to see the real image.

Digital cameras generally offer noise-reduction features that improve the result, but this is done in ways that generally don't help the landscape photographer. Simplistically speaking, noise reduction blurs the image to hide the noise, then sharpens it back up so the image looks good. However, most noise reduction ends up hiding the fine detail that landscape photographers want, so it is best to avoid noise problems if you can. While technology will undoubtedly improve in this area, if you're using a digital camera to shoot landscapes, use your camera's normal sensitivity setting and use a tripod if light levels are low.

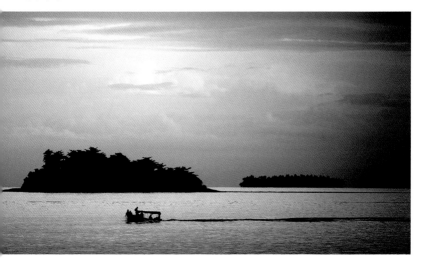

PLANNING & RESEARCH

Many photographers prefer to explore the world without preconceived ideas so they can respond instinctively to what they see. Just taking their camera with them wherever they go will present a myriad of photo opportunities.

Other photographers are more successful if they have a structured approach to their photography. Certainly, if you're travelling, it pays to research your destination before you get there – it would be really disappointing to find out later that you turned left instead of right and missed the opportunity of a lifetime. Ignorance might be bliss, but knowledge is power. Generally speaking, a little time spent planning will pay big dividends.

RESEARCHING YOUR LOCATIONS

If you have a particular destination in mind it pays to do a little research before taking your trip. Research will help you avoid disappointment and can give you ideas for different viewpoints or even different locations. The more knowledge you have, the better. Research

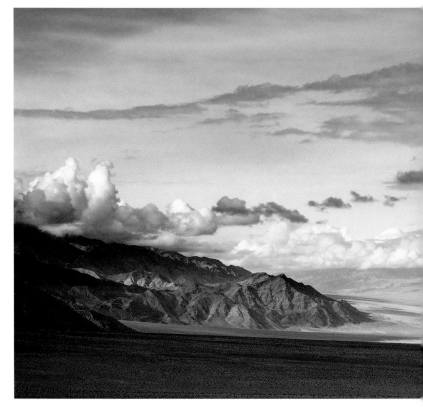

can take many forms – travel guides and the Internet are great resources when it comes to planning.

Timing can have a big impact on your landscape photos. As a traveller, it's unlikely you'll be able to spend days, weeks or months hanging around for the perfect photo opportunity. Sometimes a great landscape needs special light, a special time of year or even a special viewpoint. If you're passing through in the middle of the day, a sunset isn't possible; if you're visiting in winter, you may have to contend with snow on the mountains instead of wild flowers; and if you're only in town for a day, you might not have time to trek out to a famous lookout.

When you turn up at your destination, make a beeline for the local souvenir shop. Postcards, posters and photo books will give you lots of great ideas. They can also tell you what's not worth photographing! Add in a map of the area and a few questions to your guide or hotelier and you should be able to work out how to make the most of the time you have.

However, it is important when travelling not to be a slave to a predetermined itinerary. Some of the best photographs rely on happenstance and a little luck, so keep your mind open to new possibilities.

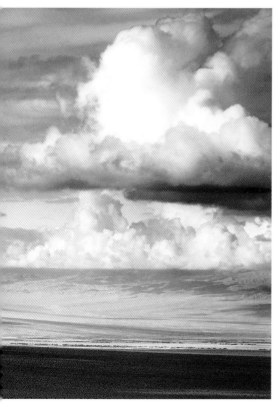

Death Valley National Park, USA

Taken from the road, this view is remarkable in its feeling of immense space. The mid-afternoon light and a slight haze accentuate the sense of distance. Many great landscapes are taken with the help of a rental car!

◀ DSLR, 100-400mm lens at 100mm, 1/4 f29, ISO 100, 4072 x 2708, RAW, tripod

WEATHER & SEASONS

One of the important things to research is how a particular destination is affected by the weather and the seasons. You wouldn't want to visit southern India during the monsoon unless you wished to photograph a lot of rain. Similarly, there's not much point visiting the European Alps in June if you want lots of white snow on the peaks – December or January would be a better bet for a winter outlook.

Many of us live in cities where life and the environment are pretty controlled, so we don't always consider seasonal factors such as closed roads in winter due to snow, unbearable summer heat in desert locations or smoggy conditions at particular times of year.

If your travel time is fixed, it's best to choose your destination to make the most of the season and likely weather conditions. If your travel time is flexible, you can optimise both destination and season.

Some landscapes change dramatically according to the seasons, while others look much the same from month to month. Photographs taken in the tropical Pacific islands will look similar whether taken in December or June (though there might be fewer sunny days in December than June). Northern Hemisphere locations can look fantastic in autumn when the deciduous trees lose their leaves and create a golden landscape, while Japan in its cherry blossom spring can be remarkably beautiful.

If you're relying on Mother Nature to turn it on for you, you should approach your travels with a great deal of flexibility and have a back-up plan in case the weather doesn't live up to expectations. Fortunately for photographers, a disappointment in one direction can often turn into a fantastic opportunity down the road.

DAILY PLANNING

Along with some idea of what you will encounter when you visit a location, it's also useful to have a daily plan of attack. This is especially worthwhile when your time is limited. If you're travelling for a week or even a month, you should work out a rough plan for each day in advance of taking your trip. On the other hand, if you're travelling for several months, it's likely you'll have longer stays at each destination, in which case you might find it more appropriate to make a series of shorter plans, perhaps at the beginning of your time at each location.

The plan should optimise your opportunities to get the photos you're looking for. For example, if you were going to photograph a desert region, sand dunes might feature on your list of desired photographs. Looking through your reference material, you would probably decide that the best sand dune images are taken around sunrise and sunset, rather than in the middle of the day. Therefore, you'd aim to be in position for sunrise and sunset each day, spending the middle of the day travelling from one location to the next. This would be an efficient use of your time.

Of course, these plans should only ever be a guide. If possible, factor in alternative plans in case the weather is bad or transport is not available. While it might be extremely disappointing not to reach a particular location, you may end up going somewhere even better. As a traveller, it pays to have an open mind. If things don't appear to be going your way, just relax and enjoy the ride.

TRAVEL MODES

Many photographers travel with guided tours. Some tours are specifically designed for photographers and provide an itinerary that ensures they reach particular destinations just at the right time for great photographs. These tours can be ideal for keen landscape photographers. Not only do you arrive fresh at your destination (someone else has taken care of all the travelling arrangements), you usually have expert guides who take you to the best locations.

General tours are not so accommodating when it comes to photography. They are often designed around restaurant bookings and invariably you'll find yourself eating breakfast or dinner when the light is the best for landscape photography. If you have some flexibility within such a tour, you may be able to disappear from time to time, but overall you could find it a slightly frustrating experience.

Sometimes great landscape photography requires a solitary approach with lots of time. If you're travelling on your own, you don't need to worry about being at dinner on time or holding up other passengers.

Travelling with another photographer is another great way to travel because you both have similar intentions – and even if you're standing shoulder to shoulder, you won't end up taking the same photographs.

If non-photographer family or friends are accompanying you, planning becomes really important. They're best off organising alternative entertainment while you photograph – let them go to the restaurant early while you stay out for the light, or send them on a ferry cruise while you trek off to the lookout for a panorama. It's all just a matter of common sense.

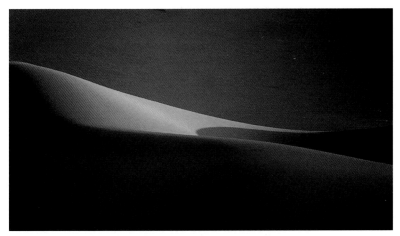

Sand dune study, Namib Desert, Namibia

While I was a guest guide on a photography tour in Namibia we were woken at 4.30am to drive 70km over poor roads. When the sun rose, the light show at the end of the road was well worth the effort.

▲ 35mm SLR, 300mm lens, f5.6, Velvia, tripod

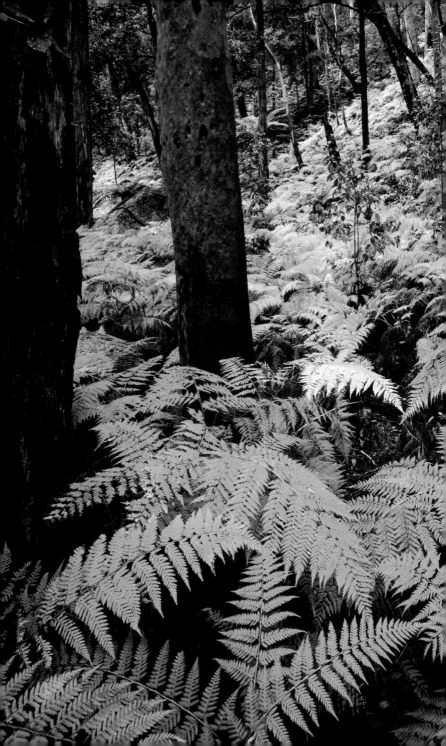

An understanding of the technical elements of photography becomes second nature to the experienced photographer. It's a lot harder to concentrate on the important issues of composition and lighting if you also have to worry about the technicalities of shutter speeds and apertures. Fortunately, there aren't too many technical aspects to worry about and you'll soon be shooting like an expert!

TECHNICAL
ELEMENTS

Fern forest, Blue Mountains, Australia
◀ 4 x 5in large-format camera, 65mm lens, 1/8 sec f22, Velvia, tripod

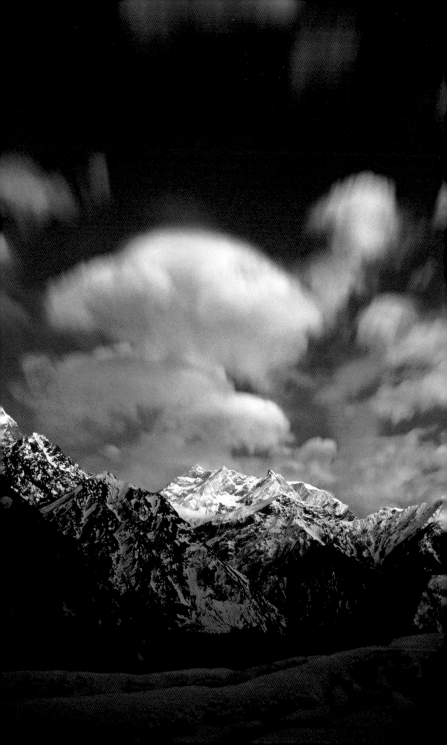

EXPOSURE

Correct exposure in a photograph provides the viewer with information about shape, form, texture and colour. This information is essential if viewers are going to recognise and understand your subject. If important areas in an image are too dark or too light, there will be no discernable detail.

Having acknowledged the importance of correct exposure, it could also be said that there's no such thing as 'correct' exposure, since it is often a matter of opinion. There can be more than one correct exposure, and while a particular exposure is often determined by your camera, it is really a question of which exposure is right for your purposes.

EXPOSURE BASICS

When you look at a landscape, your eyes see it at the correct exposure. In general, you want the photograph of that landscape to look the same – at least as a starting point.

The first thing to understand about exposure when comparing your photographs to what you saw is how remarkable our eyes and brain are at interpreting things. Many scenes have a huge range of brightness values, from very dark shadows to incredibly bright highlights. Our eyes immediately compensate for these differences, with the irises opening up wider to look into the shadows (so more light reaches us) and closing down when looking at highlights (so less light reaches us). Our eyes (with a little help from our brains) are constantly making adjustments to even things out so that everything we see is correctly exposed.

Cameras are not so adept. The film or digital sensor used to record the scene has just one chance at getting the exposure right. Unlike the eye, which constantly adapts as it looks around a scene, the camera must expose the same way across the entire scene. It cannot lighten some areas and darken others at the time it makes the exposure (although we can do this later in the darkroom or with a computer).

For the camera, the problem is that many landscape scenes have a range of brightness values that far exceeds that of the film or digital sensor being used to record them.

The Zone System

To help explain how exposure works, some photographers talk about the Zone System developed by the father of landscape photography, Ansel Adams. The Zone System uses a range of brightness values from black to white, which roughly matches the range that can be captured on film or a digital sensor. Zones 0 and 1 are black and near black respectively, and zones 9 and 8 are white and near white. These four zones don't provide very much subject information, so if you want to see good detail, texture and colour in your subject, you have to fit your subject into zones 2 to 7 – a range of six zones.

If the scene being photographed has more than six brightness zones, problems can arise if you want the whole scene to be full of detail. For instance, if there are 15 brightness zones (such as you could find on a bright sunny day at the coast), at least nine of these zones are going to end up with little or no subject detail. These areas are considered underexposed or overexposed.

Kalopani, Annapurna Circuit, Nepal
◀ 35mm SLR, 20mm lens, 4 secs f2.8, Kodachrome

Most photographs need some areas that are very dark and very light – there are, after all, deep shadows and bright highlights in most landscape scenes. The key to correct exposure is to position the most important areas in your photograph within the six zones of detail, texture and colour.

When a camera meter determines the exposure for a scene that has a greater brightness range than it can handle, compromises are made. Normally the compromise is pretty good, but not always. As photographers, it's our job to realise the limitations of exposure and make decisions that suit us, rather than relying wholly on the camera. If a scene has a brightness range that exceeds the capacity of the film or digital sensor, then a correct exposure is one that correctly records the most important areas – and it's up to you to determine which areas are most important.

Film & Sensor Latitude

Film and digital sensors have limited latitude. While the landscape we are photographing might have a subject luminance or brightness range of 10 to 20 stops, film and sensors can only satisfactorily record between five and seven stops, depending on their type.

Colour slide film has only very limited exposure latitude and is consequently the hardest film to correctly expose. Colour negative film, used to make colour prints, has much wider latitude and is more forgiving. Digital capture is also forgiving because of what can be done afterwards on your computer, but to get the best digital images your exposure should be as accurate as possible.

A film or sensor that can only record six stops of exposure has a problem when asked to record, say, 10 or 12 stops of exposure. This is a common occurrence. In practice the camera averages out the subject luminance and determines an exposure that sits somewhere in the middle. The really bright areas are recorded as white and the really dark areas as black. Generally, we accept this as looking normal.

Generally speaking, you can't stretch a film's latitude to fit a scene; you have to choose which part of the scene you want to record and which part you will sacrifice as an area of black or white. Correct exposure becomes a matter of deciding which parts of the image are the most important.

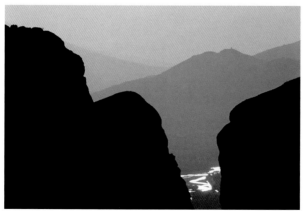

Valley highlight, Meteora, Greece

This image has a huge range of brightness values. The mountainsides in the foreground are underexposed (zone 0 or zone 1); the river at the valley floor is reflecting sunlight and is overexposed (zone 9). Only the background hills are correctly exposed – they have colour and some hazy detail.

◀ 35mm SLR, 100-300mm lens, Velvia, tripod

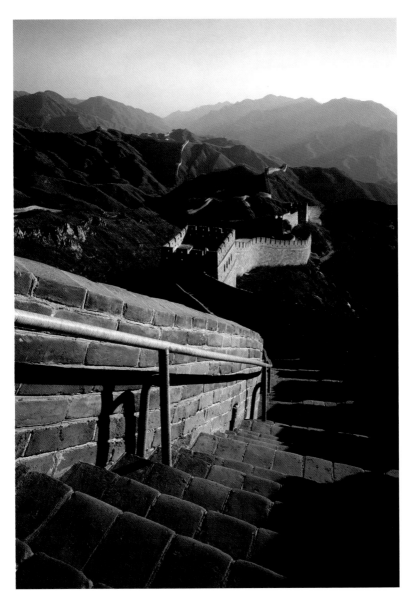

Great Wall, China

One side of the wall is in bright sunshine, and the other is in deep shadow. It would have been possible to show more detail in the shadows by increasing the exposure, but this would also have lightened everything else. By keeping the sunny side of the wall at around zone 5 (a middle value), the sky isn't washed out and the contrast in the shadows gives the scene added drama.

▲ 4 x 5in large-format camera, 65mm lens, f32, Velvia, tripod

EXPOSURE CONTROL

Aperture & Shutter Speed

An exposure is a measure of a quantity of light. Your light meter, normally built into the camera, will tell you how much light is required in terms of a lens aperture and a shutter speed.

To understand how apertures and shutter speeds work in relation to the other, think of your film as a garden, and the lens and shutter as a hose. The longer you turn on the hose, the more water will get through. This is the shutter speed. It determines how long the film is exposed to light.

Now, if you have a very thin hose, it will take you longer to water the garden than if you have a wide fire hose. Thus, the wider the opening in the lens (the aperture), the more light can travel through.

The quality of light used to expose the film is a bit like the water pressure behind the hose. Midday sunlight is very strong, while an indoor tungsten globe produces relatively low intensity light. Moonlight is softer still.

Once you know how strong the light is (the meter will tell you), you have a choice of aperture and shutter speed combinations that will give the correct exposure.

The size of the aperture is controlled by a diaphragm (or iris). Apertures are measured in steps called stops or f-stops (each stop corresponds to a 'zone', also called an EV or exposure value). Each setting is half the stop before it and double the following stop. In other words, f5.6 lets in half the amount of light that f4 lets in, but double the amount of light that passes through f8.

Working in the field, Inca Sacred Valley, Peru

When shooting relatively stationary subjects and using a tripod, almost any shutter speed/aperture combination will work. This image was taken during a short journey break on a hillside, looking down into the valley with a telephoto lens.

▲ 35mm SLR, 100-300mm lens, f8, Kodachrome 64, tripod

The series of aperture values is as follows: f1, f1.4, f2, f2.8, f4, f5.6, f8, f11, f16, f22, f32, f45 and f64. These can be worked out mathematically, but you'll find it easier to simply commit them to memory. If you ever forget, you'll find them etched onto your lens' aperture ring or on the LCD read-out panel on your camera.

Shutter speeds are easier to remember and follow the same principle that each speed is half as long as the one before it and twice as long as the one after it. The difference between each step is also equal to a stop of exposure, just like apertures. The series of shutter speeds goes something like this: one second, 1/2, 1/4, 1/8, 1/15, 1/30, 1/60, 1/125, 1/250, 1/500, 1/1000, 1/2000, 1/4000 and 1/8000 of a second. Not all cameras have all these shutter speeds. You can also see that some slight adjustments are made – 1/8 of a second isn't exactly twice as long as 1/15 of a second, but it's close enough. Again, you'll find these numbers on your camera's shutter speed dial or the LCD screen.

Different shutter speed and aperture combinations can give you the same exposure. For instance, 1/60 of a second at f16 is the same as 1/125 of a second at f11 because 1/125 provides half the amount of light as 1/60, while f11 provides twice the amount of light as f16. In fact there is a whole range of aperture and shutter speed combinations that will provide the same exposure. For instance, 1/60 at f16 is also the same as 1/250 of a second at f8, 1/500 at f5.6, 1/1000 at f4, 1/2000 at f2.8 and 1/4000 at f2.

If your camera doesn't have a 1/2000 shutter speed, for example, or the lens doesn't open up to f4, then some of these combinations will not be possible with your equipment.

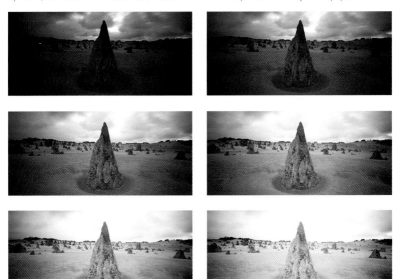

Rock formation, The Pinnacles, Australia

Correct exposure is as much a matter of opinion as it is of fact. When presented with these six images, most readers will agree the top left and bottom right images are not 'correct', but the other four will each have their advocates.

▲ DSLR, 16-35mm lens, 30 secs f22, ND filter, tripod. Image differences created digitally.

Light Meters

There are three exposure values found in most images – white, black and a middle grey. This middle grey is also called 18% reflectance grey and it sits in the middle of the range of brightness values from white to black. (In the Zone System it is zone 5.)

Middle grey is important. In theory, if you take all the values in a scene (whether in colour or black and white) and average them out, you will end up with middle grey. Obviously, not all scenes will work like this – a white polar bear in a snow blizzard would not produce an average of middle grey but very light grey. However, the theory usually holds, and every time you point your camera at a scene, the camera is working out an exposure that produces an average of middle grey.

This middle grey approach sometimes works with landscapes, but sometimes it doesn't. In a landscape, we usually have a very bright area at the top (the sky and clouds) and a much darker area below (the landscape). An average exposure can produce a sky that is too bright and a landscape that is too dark. It is often best to get the landscape right and fix the sky by using a graduated neutral density filter or by using an image-editing program.

Most cameras have two or three different metering systems: centre-weighted, spot and/or matrix.

Centre-weighted meters place more emphasis on the middle of the scene when determining the exposure because this is where the subject usually is. However, it's a bit hit-and-miss.

Spot metering reads a very small area of a scene, but it requires some experience to use. You spot meter an area in your scene that you wish to have exposed as a middle value (a zone 5), and then trust the rest of the scene will fall into place.

The metering solution favoured by most camera manufacturers today is a matrix metering system. It takes a number of exposure readings from different parts of the scene (from two to 35 readings, depending on your camera model) and then compares the result against a database of prior results to determine the best exposure.

When metering systems work properly, everyone is happy. However, a meter doesn't know what you're pointing it at. All it does is turn your subject into an exposure for middle

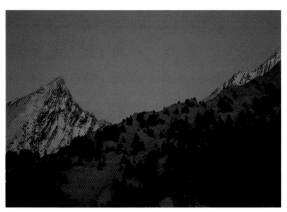

Looking to Les Arcs from Courcheval, France

We all know snow is white, but white in a photo doesn't tell us very much. In this image, the snow is blue or orange and its value is also a long way from zone 8 or 9. Sometimes a literal interpretation of exposure values isn't the best way to communicate what you've seen in a landscape.

◀ 35mm SLR, 100-300mm lens at 300mm, f8, Velvia, tripod

grey, so if the most important part of a scene isn't middle grey in tone, you will need to adjust the exposure. For instance, most of us would want to record snow as a very light, almost white tone. However, a metering system may try to record your snow as a middle grey, so you would need to manually adjust the exposure accordingly (in this case, the exposure would be increased by one or two stops).

EXPOSURE COMPENSATION

To recap, all light meters, regardless of their type, are designed to record a scene's brightness values as an average of middle grey.

If you photograph a white wall, the meter will recommend an exposure that records the wall as mid-grey. If you photograph a black wall, the meter will recommend an exposure that records the wall as mid-grey. And if you photograph a colourful wall full of graffiti, it will average out the colours to produce an exposure equivalent to mid-grey.

Out in the real world, few of us photograph plain walls, so the meter takes all the subject luminances found in a scene into account and works out an average. As long as our scenes have an average distribution of light and dark tones, or high and low subject luminances, then the recommended exposure will usually be correct.

However, sometimes your scene won't have an average distribution of tones. A snow scene, for instance, has a lot of very light tones and if these are averaged, we end up with a grey wall syndrome.

While minor changes can be made after exposure (unless you're shooting colour slides), it's best to get an accurate exposure in the first place. Most SLR cameras have an exposure-compensation feature that allows you to adjust the meter reading up or down to increase or decrease the exposure. Most allow adjustments in one-third-of-a-stop increments, up to a total of four stops in some cases.

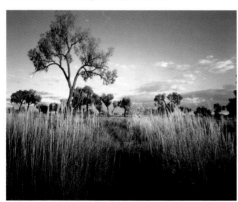

Grasslands, MacDonnell Ranges, Australia

The foreground is very dark and would be considered 'underexposed', but taken in context with the rest of the image, it is 'correctly' exposed as it represents the shadows in the scene.

▲ 4 x 5in large-format camera, 65mm lens, 1/4 sec f32, Ektachrome, tripod

If you look at a landscape and decide that it should be lighter than a mid-grey average, you might decide to use the exposure-compensation feature to add exposure. Conversely, some landscapes might look better a little darker. How will you know to make a particular scene lighter or darker? If you're shooting with film, this only comes with experience, but while you're learning, you can bracket your exposures (see next section). For digital photographers, you only have to look at the camera's review screen and the histogram to see if your exposure is correct (see Histograms, p45).

BRACKETING

Many professionals bracket their photos. Bracketing is simply the process of taking three, five or even seven photographs of the same subject, but with different exposures. In addition to the recommended exposure, they underexpose and overexpose additional images. By bracketing, they are ensuring they have the correct exposure, just in case they haven't worked it out correctly during the shoot. It's a form of insurance.

A standard bracket is minus one stop, normal and plus one stop, but sometimes this bracket can be a bit dramatic. For precise technical work, exposure brackets might be in one-third or one-half stops.

For night photography, a better bracket is normal, plus one and plus two exposures, as it is very rare for a night photo to require less exposure than the meter reading (if indeed you have a meter reading!).

Many new SLRs have a bracketing feature that takes a series of different exposures automatically. These allow three, five or seven exposures in steps of one-third, one-half or full stops. Bracketing is extremely useful when shooting transparency film, but it is equally applicable to negative and digital shooters as well.

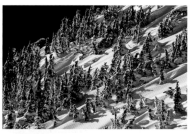

Fresh snow, Whistler Mountain, Canada

Exposure is not just a matter of science, it's also a matter of taste. This bracket of three images shows the difference a full stop either side of the camera's recommendations can make. Seen in isolation, all three could be considered quite acceptable, so it is a matter of opinion as to which is better.

◀ 35mm SLR, 100-300mm lens, f11, Velvia

◀ One stop less exposure

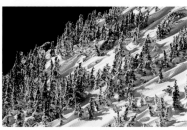

◀ Camera's recommended exposure

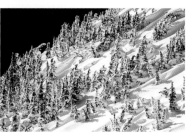

◀ One stop more exposure

HISTOGRAMS

While film photographers can be left guessing about their exposures until the film is processed, digital camera users can see the effect of their exposure immediately after capture. This is because all good digital cameras have a histogram display option on their LCD screen. A histogram is a graph of all the brightness values in a scene, ranging from black on the left to white on the right.

After taking a photograph, you should look at the histogram to check the exposure. If the graph shows a relatively even range of values from white to black, with the majority of values in the middle, you have a correct exposure. If your histogram has all its values to the left, the image is underexposed and you need to increase the exposure. If the values are all to the right, the image is overexposed and you need to decrease the exposure.

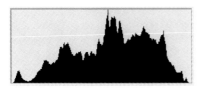

Histogram display

The histogram is not the most exciting thing to look at, but it provides a wealth of information. A good exposure will have the majority of brightness values in the middle of the graph, without too many at either end.

CONTROLLING IMAGE SHARPNESS

There are many different shutter speed/aperture combinations that produce the same correct exposure, but different combinations can affect other aspects of the photograph. When the aperture is changed, it alters depth of field. When the shutter speed is changed, it can affect the sharpness of the subject.

Most professionals won't use 'program' exposure mode where the camera is left to set both the aperture and the shutter speed, because they have no control over depth of field or blur. Instead, they will use aperture-priority, shutter-priority or manual exposure modes so they can choose the aperture or shutter speed that best suits the subject.

In some cases, selecting the aperture is more important than the shutter speed (eg when shooting a landscape); in others the shutter speed takes priority (eg when you want to freeze action). Sometimes both are important and a compromise is made.

Depth of Field

Image clarity or sharpness is not just a matter of focussing the lens on the subject. There is an area in front of and behind the sharp focus plane that is also sharp or clear, and the extent of this area changes, depending on the focal length of the lens, the focussing distance and the aperture used. This three-dimensional area of sharp focus is called depth of field.

The area that is sharp increases as the aperture becomes smaller. At an aperture of f2 or f2.8, there might be next to no depth of field at all. This is sometimes referred to as using the lens 'wide open', because the lens is at its maximum aperture. However, at f8 (a middle aperture) depth of field might increase the area of sharp focus from 9m to 11m from the lens. Anything closer than 9m or further away than 11m would still appear unsharp. At

a still smaller aperture (note that the smaller apertures have larger numbers) such as f22, depth of field could be as great as 5m to 18m.

By understanding depth of field, you'll take a step towards controlling the most important aspect of image clarity in a landscape. A landscape photographer generally wants everything from the foreground to infinity in sharp focus, so a small aperture such as f22 is often chosen because it maximises depth of field. Occasionally landscape photographers like to isolate a subject within a scene. For instance, if you wanted to isolate a tree or a rock against a blurred background, then the widest aperture would be selected, say f2.8, f4 or f5.6, depending on the lens.

Depth of field is also affected by the focus distance and the focal length of the lens you are using. Depth of field is much greater at longer focus distances, and shallower at closer distances. For instance, if your subject is a distant mountain range, all of the apertures on your lens will produce a sharp, clear image, and depth of field is not important.

On the other hand, if you're taking a detail of some rocks or shrubs and the focussing distance is only 1m or 2m, then depth of field is much shallower. You need a much smaller aperture to ensure everything appears to be in sharp focus.

Wide-angle lenses (with a focal length of less than 50mm) provide more depth of field, while telephotos (with a focal length longer than 50mm) offer much less.

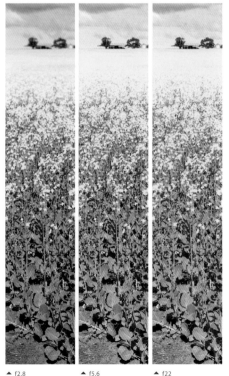

▲ f2.8 ▲ f5.6 ▲ f22

Depth of field

To see the effect of depth of field, compare the top and bottom of each of these three photos. The lens was focussed on the flowers in the foreground. At f2.8 (a wide aperture), the flowers are sharp enough, but the barn in the background is blurred. Stopping down the lens to f5.6 (closing the aperture to a smaller size) doesn't affect the sharpness of the foreground, but now the background looks less blurred. At f22 (the smallest aperture on the lens), the barn also appears sharp as the lens produces its maximum depth of field. If you want as much as possible to be sharp and clear, use the smallest aperture available to maximise depth of field.

◄ DSLR, 16-35mm lens, ISO 100, 4072 x 2708, RAW, tripod

Hyperfocal Distance

The hyperfocal distance is the point you focus on when you want to maximise the amount of depth of field in a photograph.

When you focus on a landscape at infinity (the furthest focussing distance for the lens), the depth of field will increase the area of sharp focus in front of and behind infinity. However, there is nothing 'behind' infinity to focus on, so it is wasted depth of field.

If you were to focus on a point closer than infinity, the depth of field could extend the area of sharp focus out to infinity and bring closer areas into focus as well. This is called the hyperfocal focussing point. For example, if you focus your lens on infinity, depth of field might bring the closest point of sharp focus to 10m, but if you focus on 12m, depth of field might extend back to infinity and forward to 7m. You have increased the area of sharp focus by 3m, and this can be the difference between having a sharp foreground and a blurred one.

In order to locate the hyperfocal focussing point, most lenses come with information sheets that will give you precise distances. Many lenses also have a focussing scale on the lens that indicates depth of field for different apertures and can be used to set the hyperfocal distance. This depth-of-field scale has two marks for each aperture, one on each side of the sharp focus point. For example, if you set the aperture at f22 and focus your lens at infinity, depth of field might extend from infinity to around 3m. By refocussing your lens so the infinity mark sits above the f22 indicator (and critically sharp focus is around 3m), depth of field will now extend from infinity to around 1.5m.

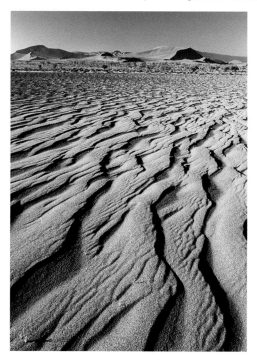

Sand texture, Namib Desert, Namibia

By focussing first on infinity, and then pulling the focus back to around 1m (the hyperfocal distance for this lens), depth of field extends from the bottom of the frame to infinity.

▲ 35mm SLR, 20mm lens, f22, Velvia, tripod

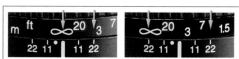

Setting the hyperfocal distance

By positioning the infinity focussing position on the f22 mark, depth of field can be increased from 1.5m to infinity, instead of just 3m to infinity.

SHUTTER SPEEDS & MOVEMENT

If you use a small aperture setting to achieve more depth of field, you will require a longer shutter speed to compensate on the exposure side. Longer shutter speeds can have dramatic effects on images, especially when it comes to capturing movement. Shutter speeds allow you to freeze movement or record it as a blur. There are two types of movement to contend with: subject movement and camera movement. Both can produce image blur, but this blur has nothing to do with how the lens is focussed. It concerns the position of the subject within the image frame. If the subject's position moves during the exposure, then blur results.

Camera Shake

A 1/30 of a second shutter speed is often touted as being the slowest shutter speed at which you can successfully hand-hold a camera. Any slower (longer) shutter speed than this usually leads to 'camera shake', the blur that results from moving the camera during the exposure. For landscape photography, this is rarely a problem because the solution is to simply mount your camera on a tripod.

In fact, you could probably hand-hold a camera mounted with a wide-angle lens for longer than 1/30 of a second without any *noticeable* camera shake. As a rule of thumb, the slowest hand-held shutter speed is the reciprocal of the focal length. A 20mm lens can be hand-held for 1/20 of a second, but a 300mm lens can only be hand-held for 1/300 of a second or faster.

As with all things photographic, it's a matter of magnification. Any slight camera shake is magnified with a 300mm lens but might not be noticeable in a postcard-size print taken with a 20mm lens. But it's still there, so for the best possible quality landscape photos, we recommend eliminating camera shake by tripod-mounting your camera.

If you're caught without a tripod, it's a good idea to hold your breath while taking the photo and to find something against which you can support either yourself or the camera.

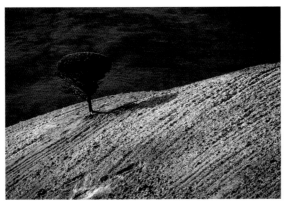

Solitary tree in a field, Volterra, Italy

While this image could have been comfortably taken hand-held, I didn't want to chance losing the fine detail due to camera shake. The answer was to use a tripod and wait until the moving clouds above highlighted the tree while the distant hills were in shade.

◀ 35mm SLR, 100-300mm lens, f8, Velvia, tripod

Subject Movement

Apart from camera shake, you also have to consider subject movement. Generally speaking, landscapes are considered to be fairly stationary – they're not likely to jump up and run away. However, wind through the trees, clouds racing across the sky, falling water and crashing waves are all examples of movement you're likely to find in a landscape.

Whether a particular shutter speed is fast enough to freeze the action depends on how fast the action is. A zephyr fanning a grassy steppe will probably appear tack sharp with a shutter speed as slow as 1/30 of a second, while a palm tree bending under a typhoon's fury would probably be blurred. The faster the action, the more movement within the frame, and the shorter (faster) the shutter speed needs to be.

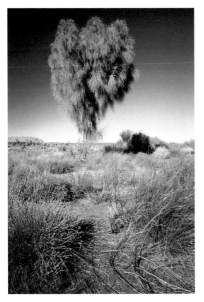

Any movement will be blurred no matter what the shutter speed – it's all a question of degree. Depth of field works on the principle that the human eye has limited resolving ability and the same principle applies with shutter speeds. As long as the movement is sufficiently minor, the subject will appear sharp and frozen in time.

Many of the images photographed in this book were taken with shutter speeds slower than 1/30 of a second – some with time exposures of several seconds – yet the images look completely sharp. When it comes to landscapes, you don't need to worry too much about the shutter speed.

Desert tree, Yulara, Australia

The small aperture of f32 and slow ISO 50 film required a long shutter speed. Movement is visible in the leaves blowing in the wind.

◀ 4 x 5in large-format camera, 65mm lens, 1 sec f32, Velvia, tripod

Intentional Blur

When photographing landscapes, the general approach is to set the aperture for the required depth of field, then mount your camera on a tripod and don't worry about the shutter speed. If there is a little bit of blur in leaves or a waterfall, accept it. When some parts of a scene are blurred but others (such as rocks and tree trunks) are sharp, the image looks quite natural and believable.

The most common use of shutter speeds as a creative control in landscapes is with waterfalls, recording the falling water as a silver sheen rather than individual droplets. The technique is easy to achieve, but you must use a tripod. Photos with subject movement look good because there is a sharp reference point. For instance, with a waterfall photo, the rocks are recorded sharply; it is only the water that is blurred. Were the rocks and the water both blurred (due to both camera shake and subject movement), you would have quite a different result.

The shutter speed you select will depend on how much the subject is moving, and how much you wish to blur the subject. There is no single rule to determine the shutter speed, though a little experience will indicate that 1/15 or 1/8 of a second will give you a subtle amount of blurring, while 1/2 or one second will give you a lot of blur.

Some photographers fit a neutral density filter or two over their lens, reducing the amount of light passing through the lens so they can use very long shutter speeds of up to several minutes. The result can be quite startling as clouds moving across the sky may blur. The other technique is to simply wait until after the sun has set (or to get up early before sunrise) and shoot your landscapes in the dim twilight. Because there is so little light, you will need to use long shutter speeds for correct exposure – and you'll produce some beautiful blurs if your subject (or part of your subject) is moving.

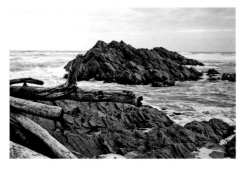

Shutter speeds for blur

These images show the effect the shutter speed has on the amount of blur created by waves breaking on the rocks. If the water was moving more slowly, longer shutter speeds would be needed to create the same amount of blur; if the water was moving more quickly, shorter shutter speeds would be sufficient. Note also how the changing aperture affects depth of field.

◄ DSLR, 16-35mm zoom lens,
 ISO 100, 4072 x 2708, RAW, tripod

◄ 1/10 sec (f2.8)

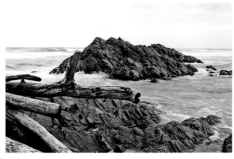

◄ 1 sec (f8)

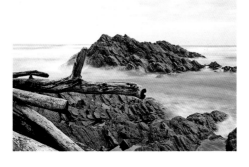

◄ 6 secs (f22)

EXPOSURE MODES

Many cameras have an automatic 'program' exposure mode (often called Program AE, where AE means 'automatic exposure'). In this mode the camera selects both the shutter speed and the aperture for the correct exposure. There are usually several different shutter speed/aperture combinations for any particular situation, but the choice can have a significant effect on depth of field and subject movement.

The standard program modes usually go for a middle-of-the-road setting, as long as the shutter speed is fast enough to prevent camera shake. These settings are not necessarily the best for landscape photography. Special program modes (such as action and landscape modes) give priority to fast shutter speeds, maximum depth of field, minimum depth of field and so on, depending on the function of the mode.

It's not always a good idea to hand over complete control of exposure to the camera. Once you understand depth of field and shutter speeds, it's best to use one of the semi-automatic modes (called aperture-priority and shutter-priority) to give you greater control. Aperture-priority mode is perhaps the best option because when you set the aperture you are also choosing the depth of field you want in the image. Operation is still automatic because the camera sets the shutter speed for you. You can also keep control over shutter speeds indirectly when using aperture-priority mode if you keep an eye on the exposure settings.

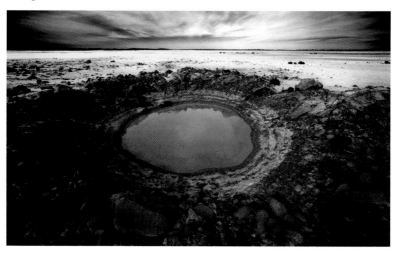

Blast crater, Lake Yindarlgooda, Australia

A 14mm ultra wide-angle lens has been used at its minimum aperture to maximise depth of field. Digital post-production techniques have also been applied to enhance the colours, notably the orange water and yellow earth.

▲ DSLR, 14mm lens, ISO 100, 4072 x 2708, RAW, tripod

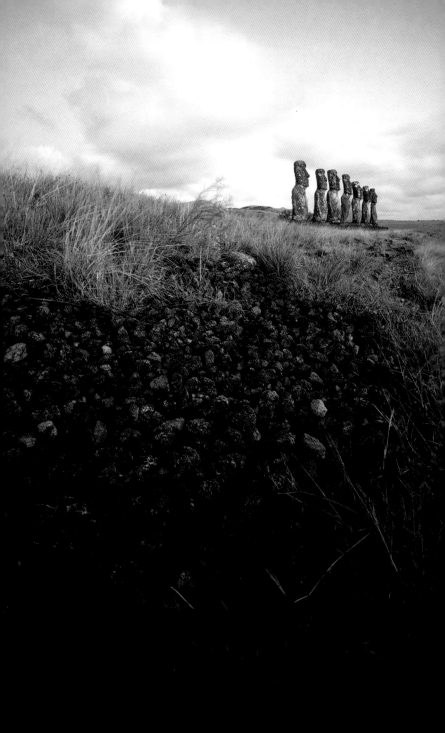

COMPOSITION

Composition is the art of positioning your subject within the frame. It also involves using colour, scale, pattern, repetition and viewpoint to create a more pleasing photograph.

While there are some basic rules of composition we can all follow to improve our photographs, composition takes time and experience to learn. It's as much about feeling and emotion as position and size. It's also about breaking the rules to create something even better, but it's certainly best to know the rules first. Photographers who break the rules without knowing them usually create images that are plain boring or even awful.

One of the best ways you can learn composition is to program good compositions into your subconscious. You can do this by looking at lots of good photographs so that when you see a scene it will prompt a response. This is not copying another photographer's work; rather, it is a matter of taking inspiration from them. Landscape photography books and photography magazines can both be a great help. The Internet is also a great resource, as most serious landscape photographers have websites displaying their best work. Take a look and spend some time analysing why you like some photos and dislike others. Sometimes it will be the subject that appeals to you, while in other cases it will be the lighting. Also look at where the subject is positioned in the frame, how the various compositional elements are placed in relation to each other, and how the photographer has used compositional lines, shapes, patterns and colour to make the photograph more striking.

As you learn more about composition, you'll find you prefer some rules over others and you'll start to develop your own photographic style – and this is what it's all about. The more photographs you take and the more time you invest in creating striking landscape images, the better your photos will become.

CONTENT SELECTION

Although not strictly a compositional element, content selection is an incredibly important step in the creative process. While a particular subject won't necessarily create a great photograph, some photographers interact better with particular subjects (or content). One photographer might be unable to make a brick wall look interesting, while another will create a masterpiece with the same subject.

Make sure you photograph a subject that interests you. There might be a particular area near your home or an exotic location overseas that would make wonderful landscape photographs. Or you might love sunsets or rainy weather – your subject could be different locations at sunset or landscapes on rainy days. If you pick a subject that you are passionate about, it will show in your photographs. You'll also enjoy spending time taking the photographs and the results will speak for themselves.

However, not everyone will share your passion. This is when you have to make a decision about whether your photography is for you or to share with others. For instance, most Australians and Americans love Italian landscapes, especially those featuring villages in a picturesque location; the romance of Europe and its history makes these photographs more interesting and appealing. However, for the Italians who drive past such locations every

Moai, Easter Island, Chile

day on their way to work, these villages have minimal appeal. Now show the same Italian audience a photograph of outback Australia or perhaps the Sydney Opera House at sunset with the Harbour Bridge in the background and they will respond more positively than someone who passes the Opera House on the ferry every day.

If you wish to share your photographs with others, it's important to choose subjects that will interest them or else photograph common subjects in unusual ways to create interest. People are inundated every day with hundreds of images, and television provides thousands more. If you want people to respond positively to your landscape photographs, you have to put the odds in your favour by selecting appealing subject matter, or photographing more common scenes in an appealing way.

Not everyone wants to impress their friends and family with their photographs. Some photographers are quite happy shooting images for themselves – and there's nothing wrong with this approach. Shoot whatever you wish, but shoot so you are happy with your results, and think carefully about your subject matter.

Tuscan hill town, Italy

Photographed on a rainy day in black and white, the image was printed very darkly and the individual buildings lightened with a paintbrush dipped in bleach (Farmers Reducer). The subject matter is evocative for Australians and Americans, but may be less so for Europeans.

▲ 35mm SLR, 300mm lens, f5.6, APX 100, tripod

Rocky outcrops, MacDonnell Ranges, Australia

The bright Australian sunshine and expansive desert conditions are likely to appeal to Europeans used to a more urban life. Note also the leading lines of the rocks and vegetation that take the eye to the horizon.

▶ 4 x 5in large-format camera, 65mm lens, f32, Velvia, tripod

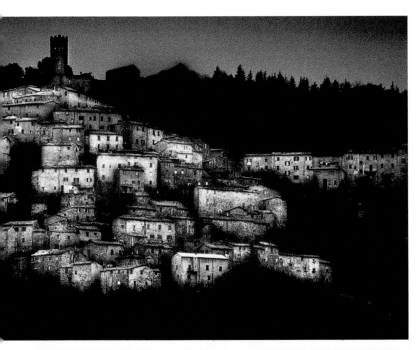

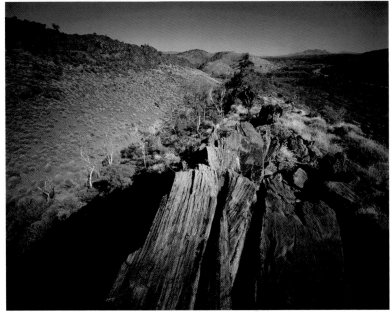

FRAMING

Many photographers are unhappy with their work because they try to include too many elements in their photographs. It's important to be discerning about what is included within the picture frame and, just as importantly, what is left out. When you're creating a landscape photograph, think first about what it is that most impresses you about the landscape. You may discover that a different framing or angle will better communicate what you like about it.

Deciding what to include in your photograph (and, equally importantly, what to exclude) is paramount. It sounds simple, but it's amazingly easy to mess up the framing in the heat of the moment. Standing in front of a spectacular landscape when the light is absolutely perfect, we tend to forget about the camera and just look at the scene. The problems arise when we see our photographs afterwards – the horizon isn't straight, there's a rubbish bin in the corner, and the subject that looked so close to us now looks like it's a million kilometres away.

The size of your subject within the frame is important. If it is too small, there will be too many other elements in the frame that are distracting. If the subject is too large in the frame, you mightn't get a sense of place or location.

In landscape photography, different points of interest often make up a great scene, and it can be tempting to simply put a wide-angle lens on your camera in order to fit it all in. Sometimes a wide-angle lens is the right decision, but don't be scared to shoot landscapes with a telephoto where you pick out a single element and make that your landscape. When you come across a landscape with lots of potential, shoot many different images – some with your wide-angle lens and others with your telephoto. By experimenting you'll soon discover what you like, and you'll probably be surprised from time to time by what works the best.

Zoom lenses are helpful for framing. If you use a zoom lens, don't just set it at its minimum or maximum focal length; use the mid-range settings to correctly frame your

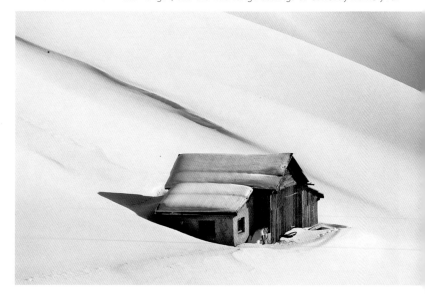

Cropping for effect

Framing, viewpoint and positioning the horizon all need to be taken into account when composing a photograph. The final image of the small Alpine barn (below left) is the end product of a series of experiments with composition.

The overview photo is taken with a medium telephoto lens and includes the whole hill and a mountain range behind. It's nice, but it's also pretty busy with the rocks on the top right and the cliff faces fighting for attention with the small hut. The solution was to zoom in and isolate (simplify) the composition.

Compare the three horizontal frames where the subject sits awkwardly in the photograph. There's not enough space in the right places to give it a sense of balance.

The best composition is the finished image, which has been cropped to a panorama and has the hut to one side of the frame.

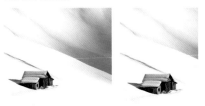

Overview of scene

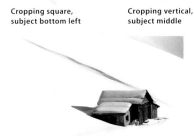

Cropping square, subject bottom left

Cropping vertical, subject middle

Alpine barn, Ciamp, Dolomites, Italy

I took this image while skiing in Val di Fassa above Campitello (sometimes it's a hard life!). Rather than taking in the whole vista, I simplified the scene by including just the hut, waiting for the clouds to darken the area behind.

▼ DSLR, 300mm lens, f6.3, ISO 100, 4072 x 2708, RAW

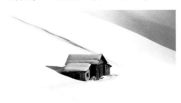

Cropping horizontal, subject bottom right

Cropping horizontal, subject centre

Cropping horizontal, subject top

image. If you own an SLR camera, then ensure you have a good range of focal lengths to choose from. A really wide angle (such as a 17mm or 24mm) will ensure you can capture the wide open spaces, while a 100-300mm zoom will let you focus on less-expansive details in the scene.

And if you don't have a zoom lens, use your legs!

VIEWPOINT

One of the main factors that determines framing is your position when you take the photograph. Many photographers reach a destination, step out of the car and take the first scene they see. Sometimes the car stops in exactly the right position, but more often than not you can find a better angle somewhere else.

Perhaps the easiest way to take better photographs is to go exploring. When you reach a popular destination or lookout, by all means take the standard photo, but then walk around. It's amazing what you will find by simply going to the side, or stepping back to include some trees in the foreground, or shooting between two rocks.

Sometimes getting a better angle will involve a lot of extra effort. Many landscape photographers will walk or trek for hours or even several weeks to get a great viewpoint or a different angle. And they will also make many trips that are relatively fruitless – there are no guarantees you'll find a better angle. However, if you're looking for photographs with power and impact, then you need an interesting and different viewpoint.

There are two other things you can do to create an interesting viewpoint: shoot low and shoot high. Most humans look at life from 1.5m to 2m above the ground, and most photographs are taken from the same height. As soon as you change the height of your camera, you create an image which looks different and potentially has more impact.

Getting down low is easy to do, but it only works if you have a foreground. If you're shooting a landscape from the edge of a cliff, then whether you're standing or crouching doesn't make much difference. However, if you are including the edge of the cliff in your frame, then a low angle will bring the rocks and grass on the cliff into view. They will appear larger in the frame (they are closer to the camera) and, if you're using a wide-angle lens, the foreground can lead the eye into the distance. There are many situations where getting down low can make quite a difference. If you have trees in the foreground, try lying down on your back and looking up, with the horizon low in the frame. Or place the horizon high in the frame and focus on the ground at your feet – the small pebbles can appear the size of boulders (this technique works best with a wide-angle lens).

The second option is to gain a higher vantage point. Some landscape photographers use a very tall tripod and carry a ladder in the back of their car or van. It's amazing how even an extra 1m or 2m altitude can change the perspective of a landscape. You can also climb a nearby hill or mountain, or jump into an aeroplane, helicopter or balloon to take a true aerial perspective.

If you choose to shoot a landscape from a different viewpoint, do it in such a way that the viewpoint suits the subject. Try not to use a high or low viewpoint on a subject just because you read about it here – you will find some subjects work well while others are not so successful. Again, it's all a matter of experience and personal preference.

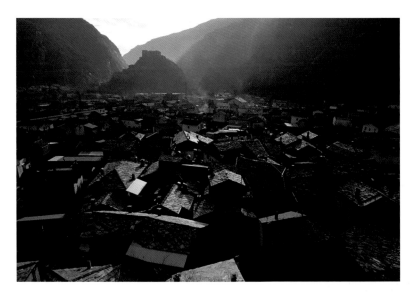

Village, Valle D'Aosta, Italy

By driving out of town on a side road, the higher elevation gave a much more interesting viewpoint – an overview with contra-jour lighting – just perfect to capture the winter smoke rising in the distance.

▲ 35mm SLR, 20mm lens, f22, Velvia, tripod

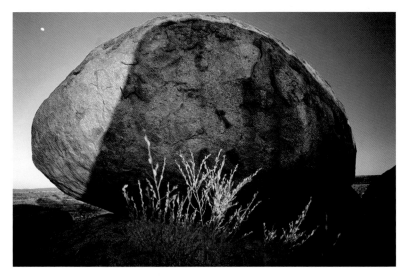

Devil's Marbles, Australia

A low camera angle means the viewer is looking up to the rock, increasing its size and lowering the horizon in the frame. Interesting late-afternoon light has also helped, with another 'marble' throwing a shadow.

▲ 35mm SLR, 20mm lens, f16, Velvia, tripod

ORIENTATION

Yet another way to create interest in your images is to simply turn your camera and shoot vertical frames. Most people use their cameras the way they were designed – horizontally. By shooting vertically, you're again creating a little more interest, though this compositional technique is not always so useful for landscape photography. A horizontal photograph is said to have a landscape format with good reason (a vertical photo has a portrait format). Nevertheless, there will be occasions when a vertical photo will work particularly well – photographs of waterfalls and tall trees are good examples.

Don't be afraid to turn your camera around if it helps your composition.

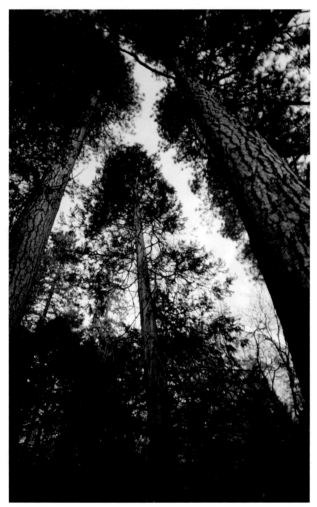

Towering trees, Yosemite National Park, USA

Some subjects, such as trees, favour a vertical composition. In this example the diagonal lines of the tree trunks lead the eye into the photo.

◀ 35mm SLR, 20mm lens, f8, Kodachrome 64

POSITIONING THE HORIZON

When it comes to landscape photography, the horizon is really just a compositional line. Compositional lines can be real or implied. For instance, a river snaking through a valley creates a curved compositional line. The sides of a building are vertical lines, while the roof might have a number of diagonal lines. The horizon is typically a horizontal line, but in the case of a mountain vista, it might be a jagged, irregular line consisting of a number of peaks and troughs.

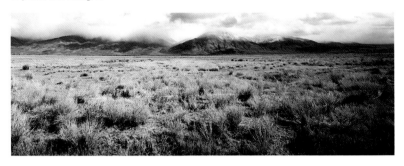

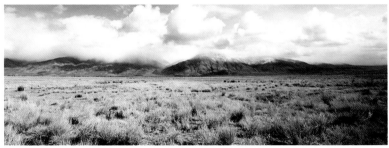

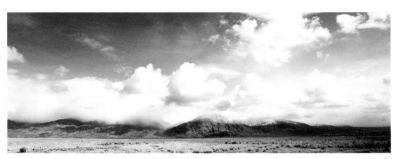

Desert plain, Highway 395, USA

There is no wrong or right with horizons, but the position will affect the way viewers perceive your landscape. If you love the grassy plain, position the horizon up high; if you want to dwell on the sky, then lower the horizon line; and if you used to be indecisive, but now you're not so sure, put the horizon in the middle.

▲ DSLR, 14mm lens, f22, ISO 100, 4072 x 2708, RAW

Implied compositional lines usually represent the direction the eye will travel between two points of interest in a composition. For instance, a photo of two trees standing in a field will have four main lines: two thick, short vertical lines created by the trees; a third that is created by the horizon; and a fourth shorter horizontal line that is implied by joining the two trees together (you can't see a line, but it's there every time your eye moves from one tree to the other). Real and implied lines are strong compositional tools.

Vertical and horizontal lines are relatively static, while diagonal lines are considered to be dynamic. The line of a horizon can be either. For instance, in the mountains, the horizon could be a strong diagonal line, produced by a ridge or the side of a peak. In the desert, the horizon is a strong horizontal line. However, unlike shorter lines, a horizon travels from one side of the frame to the other and is very powerful. In fact, the horizon dominates the composition, leaving everything else above the horizon, below the horizon or crossing the horizon.

If the horizon is the main compositional line in an image, its placement sets the scene because it determines which part of the image is most important. For instance, if the horizon is placed in the lower half of the image, there will be more sky than land and so the sky is said to dominate. You would use this position if the main subject was a brilliant sky or some thunderous clouds. If the horizon is in the upper part of the image, then the landscape is the dominant area. The mountains, valleys and trees are of more interest than the sky and this horizon placement concentrates the viewer's attention accordingly.

If the horizon is in the middle of the image, neither landscape nor sky is dominant and the message sent to the viewer is that the photographer doesn't really know what's more important. Placing objects in the centre of an image can create a staid, static feeling that provides little excitement or stimulation for the viewer. It's far better to place the horizon either towards the top of the frame or down at the bottom, positioning it so there's no doubt your placement was intentional. (In other words, don't move the horizon line just a fraction off the centre axis because it will still look like you've put it in the middle, but couldn't get it quite right!)

Of course, there are times when the horizon can happily sit in the middle of the image. You might have a reflection, for instance, and want to create a symmetrical image. More likely, however, your subject will be dominant in the frame and the horizon becomes a secondary element, possibly out of focus.

CENTRE OF INTEREST

Most photographs have a centre of interest. A centre of interest is just that – a part of the photograph that is of particular interest. Sometimes it is our subject and the reason we are taking the photo, but it could also be just a small part of a larger scene. Composition-ally it should be the most important element within the frame. For instance, it could be a single tree in a forest of trees, a tall mountain towering above a range of lesser peaks or a waterfall cascading over a precipice. Generally, centres of interest are only a small part of the frame and are used to balance the surrounding area. There can be more than one centre of interest in a photograph.

Compositionally, centres of interest are where the viewers' eyes go. They look around a photograph and generally settle on a centre of interest. As a photographer, it's your job to ensure viewers look at what you consider to be the centre of interest. For instance, there might be an interesting tree in a landscape. One way to ensure the viewers only look at this tree is to eliminate everything else from the photograph. This is where framing and viewpoint are so important, because they can help isolate the subject. Unfortunately, because of the tree's location or possibly the viewpoint, you may be forced to include other compositional elements such as more trees, shrubs or rocks. These other elements can fight for attention with the tree, so if you can't eliminate them from the scene (or you don't want to), you might have to use other techniques such as lighting, focus or post-production processing. You can also use the position of your subject within the frame to make it the centre of interest.

When the subject is positioned in the centre of the frame, it is considered to be very strong but also static and a little boring. If you position the centre of interest to the side, it is more dynamic and can suggest movement. If you're putting your subject in the middle of the frame simply because it's easy to do so, you're putting it there for the wrong reason. Another position might make a much stronger, more interesting photograph.

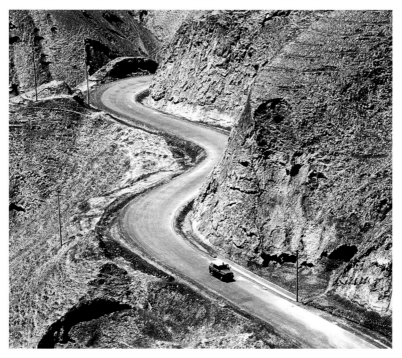

Road curves, Lanzhou, China
What is the centre of interest in this photo? In some respects, it is the road winding through the cliffs; in other respects, it's the small car. Note how the composition has been tightly cropped so that extraneous elements are removed.

▲ 35mm SLR, 75-300mm lens, f8, Velvia

BALANCE

Balance is another compositional tool and it often works in tandem with the centre of interest. When we talk about balance, we often think of two objects the same size, such as two trees the same size and shape, sitting on either side of the frame.

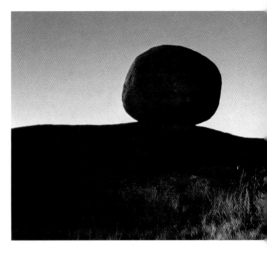

However, a ton of metal will balance a ton of feathers, even though in terms of size and area the ton of feathers will be much larger. In the same way, a small compositional element within a frame can balance a much larger element elsewhere. A small rock can balance a large rock, and a single red leaf in a tree can balance a hundred surrounding green leaves.

Compositional balance can also be implied. A lone tree in a large open expanse can appear balanced – the small tree balances the huge space surrounding it. It is considered balanced because the importance of the tree is so much greater than the empty space.

Balance is a tricky concept to explain, but with a basic understanding you can start to look at photographs in a new light. One of the main reasons particular photos work so well is because they are compositionally balanced.

RULE OF THIRDS

Once you've determined your centre of interest and you've thought about balance, you should think about where to place the centre of interest in the frame. The centre is not usually the best position; somewhere off to the side, but not too close to the edge of the frame, is better.

Many photographers use the 'rule of thirds' to help with composition and as long as you remember that rules are meant to be broken, it's not a bad starting point.

The rule of thirds is loosely related to the golden mean, a classical ratio used by the ancient Greeks and also found occurring in nature. The rule of thirds divides the frame into three sections, first horizontally and again vertically. You position your centre of interest roughly where the lines intersect.

Some cameras even overlay a simple grid in the viewfinder to help you compose better photographs, but it's not always good to be too precise in your positioning. Your centre of interest needn't be exactly on the intersecting lines – near enough is often good enough. You also don't want to position your subject on this grid if it means adversely changing your framing. There's no point including a rubbish bin in the side of your image just to get your centre of interest in the right place. It's better to first omit the rubbish bin, then get the best position possible for your centre of interest.

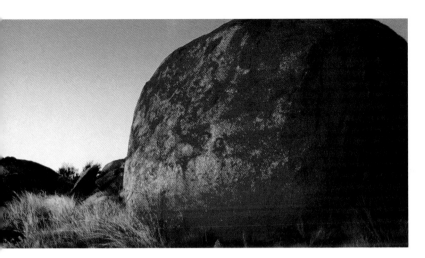

Devil's Marbles, Australia

Although the two marbles are different sizes within the frame, they are balanced. The smaller marble with its position against the blue sky takes on 'added value' for its size, so that in compositional terms it has the same importance as the marble on the right. Balance in photography isn't determined only by weight!

▲ 6 x 17cm panoramic camera, 90mm lens, f8, Velvia, tripod

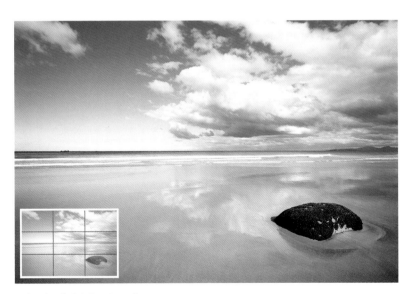

Rock on beach, St Helens, Australia

The rule of thirds is a useful tool, but you don't need to follow it too precisely. In this example, the rock is roughly in position, creating a more dynamic composition.

▲ DSLR, 16-35mm lens, f11, ISO 100, 4072 x 2708, RAW, tripod

PATTERNS & REPETITION

Sometimes several centres of interest can produce an interesting image, and if the centres of interest are all the same or similar, so much the better. Repetition as a compositional tool works well because people like to see lucky coincidences.

Some of the best repetitions are created when your framing is tight, and the objects being repeated are quite large within the frame. If the repeating objects are too small within the frame, there often isn't sufficient impact. A telephoto lens is often the best option for getting in close – you can concentrate on the repetition and exclude competing elements from the scene.

Pattern is similar to repetition, but happening on a larger scale. Patterns can be found in pebbles on a beach, tree trunks in a forest or ripples on water. Some patterns can be found in textures, such as ripples on sand dunes.

Sometimes patterns work without a centre of interest, as long as the pattern extends from one edge of the frame to the other. Patterns lose their impact if there are other compositional elements intruding into the frame. However, pattern photos are usually best presented with other images taken of the same location to give them some context.

Both pattern and repetition can work really well if there are some noticeable differences in one or more of the subjects. A row of similar trees can look great, but if the second one from the end is a different colour or missing a few branches, it creates more interest.

Palm trees,
Mentawai Islands, Indonesia

Shooting from a moving vessel, I saw this tight forest of palm trees as we rounded a headland. What impressed me most was how concentrated and green the trees were. A wider shot including the sea and the sky above would have diluted this impression. A 300mm lens with image stabilisation and a fast shutter speed helped ensure a sharp, clear result.

▲ DSLR, 300mm lens, f2.8, ISO 100, 4072 x 2708, RAW

Terraced fields,
Sacred Inca Valley, Peru

A 75-300mm zoom was stretched out to its maximum length to create this tight repetition photo. The use of similar colours simplifies the composition.

▶ 35mm SLR, 75-300mm lens, f8, Velvia

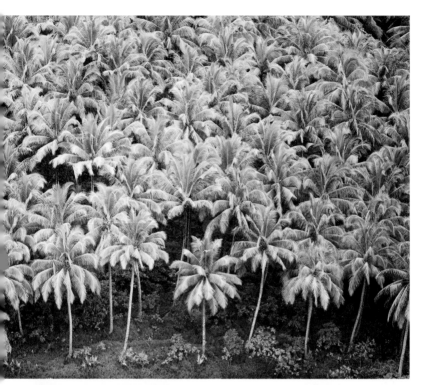

LENSES & COMPOSITION

Another aspect of composition is perspective. Perspective gives a photograph its three-dimensional characteristics, even though a photo is only two-dimensional in reality. In general, wide-angle lenses enhance perspective and telephoto lenses compress it. Compositions can be enhanced by using perspective appropriately.

Wide-Angle Lenses

When it comes to creating perspectives with incredible depth, the wider the lens the better. A wide-angle lens (ie a lens with a focal length of less than 50mm) reduces the size of objects in order to encompass more content. Consequently, there is an exaggeration of the size of nearby objects compared to more distant ones. There is also some image distortion, as the image is stretched towards the sides of the frame. The net result is an image that can have amazing depth – it sometimes feels like you can walk into a landscape captured with a wide-angle lens.

To enhance this feeling of depth, you can include a foreground object (such as a rock or a tree) so that it is large within the frame. Its relative size is exaggerated when compared with the rest of the landscape behind, and the result is very powerful.

A 28mm lens will produce some feeling of depth, but the wider you go, the easier it is to create depth. A 20mm lens is great, while a 17mm is better still. If you go even wider to a fish-eye lens, you create a great feeling of depth but there are lots of curved lines to deal with that are not always appreciated in landscape photography.

A 17-35mm zoom lens is a great tool for landscape photographers wanting to capture images with depth.

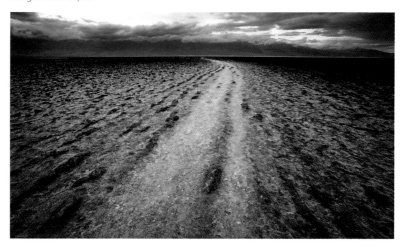

Badwater, Death Valley, USA

To take images like this you need an ultra wide-angle lens and a low camera position (around 40cm above the ground in this case); the horizon needs to be high in the frame to focus attention on the ground; and you want as much depth of field as possible. Some digital post-production has enhanced the colour.

▲ DSLR, 14mm lens, f22, ISO 100, 4072 x 2708, RAW, tripod

Telephoto Lenses

Telephoto lenses produce compression (the opposite of depth), where objects that in reality are quite distant from each other appear to be stacked up on top of each other. The longer the telephoto, the greater the effect. There is a very moderate amount of compression with a 100mm lens, while at 200mm and 300mm the effect is more obvious. If you go to a 400mm, 500mm or 600mm lens, compression is very obvious, especially in distant landscapes.

For compression to be obvious, you need to have two or more areas within the frame. A popular example is a series of mountain ranges, one behind the other. While the ranges may be 10km or 50km apart, they will look very close together in the photograph.

Compression doesn't just work with mountain ranges. It also allows you to place a subject against an unusual background, such as a tree against a mountain side instead of the sky.

And telephoto lenses are great for landscape photography because they allow you to isolate your subject and produce simpler, more powerful compositions. A 100-300mm telephoto zoom lens is a really useful tool for the landscape photographer.

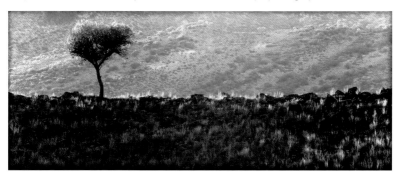

Lone tree, Flinders Ranges, Australia

A 100-400mm zoom with a 1.4x converter was used to place this small tree against the side of a larger hill behind it. Many people expect to see sky in the background, so this viewpoint gives them something to think about. It's a shot that is best achieved with a long telephoto lens.

▲ 35mm SLR, 100-400mm zoom lens at 400mm with 1.4x converter, f11, T-Max 100, tripod

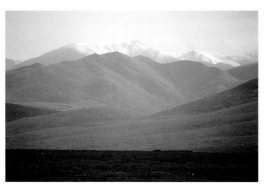

Mountain ranges, Xiahe, China

A 400mm lens has compressed the distance between these mountains. The poor light and atmospheric haze produces a moody image. Note how the colours also lighten as distance increases.

◀ 35mm SLR, 100-400mm lens, f11, Velvia, tripod

FOREGROUND, MIDDLE GROUND & BACKGROUND

Many professionals include a foreground, a middle ground and a background in their more formal landscape photographs. The technique creates a sense of depth (three dimensions) and gives the viewer an entrance to your landscape. Their eyes are drawn to the foreground, then move to the middle ground (which could be your main subject or centre of interest) and into the background (which could also be the highlight of the composition).

This is a relatively straightforward technique, but it's not always easy to put in place. For example, if you shoot from a lookout on the edge of cliff, there won't be any middle ground between you and your subject, and unless you point your camera downwards with a wide-angle lens, there won't be any foreground either. The result will be a two-dimensional image.

In this situation, one solution would be to step back from the edge of the cliff to include some foreground – you might be able to frame the landscape with the branches of a nearby tree or shoot across the top of some long grass. Admittedly, you still don't have a middle ground, but you will have created a sense of depth in your image. You could also move a long distance back from the edge of the cliff so the trees along the cliff edge become your middle ground.

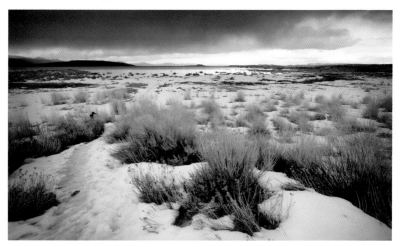

Winter evening, Mono Lake, USA

Sitting east of Yosemite in California, Mono Lake is a popular tourist destination, but in winter there are few visitors. I arrived late one afternoon as a storm was approaching.

▲ DSLR, 16-35mm lens at 16mm, f22, ISO 100, 4072 x 2708, RAW, tripod

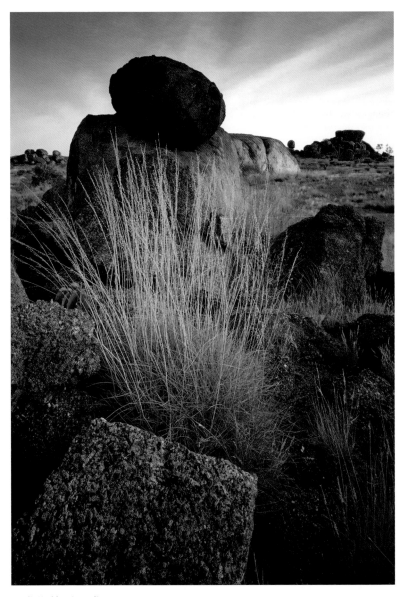

Devil's Marbles, Australia

In this example the foreground is the hero, with lots of fine detail in the rock faces and grass. In the middle ground, a 'marble' sits on top of another rock, while the background shows a rugged landscape and early-morning light.

▲ 4 x 5in large-format camera, 65mm lens, f32, Velvia, tripod

Composition Foreground, Middle Ground & Background 71

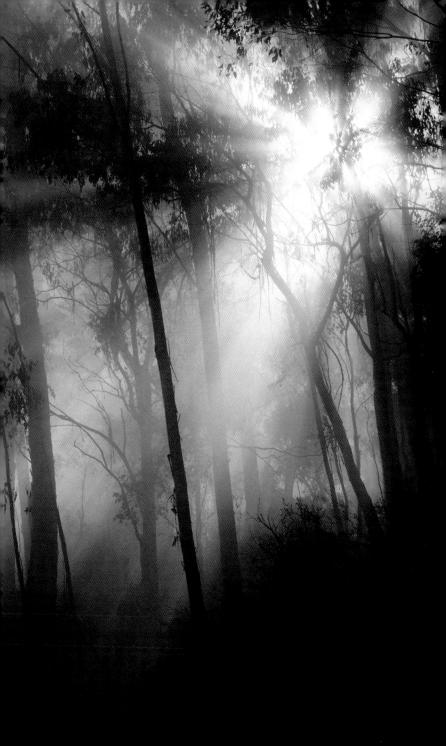

LIGHT

Composition, focus and exposure are fundamental to photography, but even the most interesting subjects can fall flat without great lighting. Good lighting can transform an ordinary subject into something fantastic.

By being aware of the types of lighting and how they affect our subject, we can look for the most appropriate locations and camera angles. A boring subject can become an exciting one simply by moving around or changing your subject's position relative to the light.

Of course, there are also situations where very little can be done to improve the lighting. Knowledge of lighting isn't a solution for dull, drab light and it can't change the weather either!

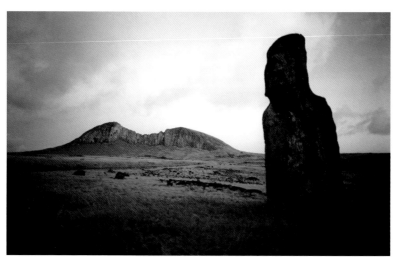

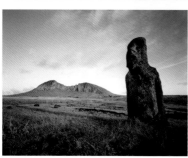
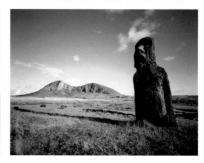

Moai, Easter Island, Chile

Look at the difference a few minutes can make. These three images were taken from exactly the same position. All that has changed is the light and the clouds in the sky. The top image was taken before sunrise, the left image as the sun was rising, and the right image a few minutes after sunrise.

▲ 4 x 5in large-format camera, 90mm lens, f32, Ektachrome, tripod

Sunrise in forest, Snowy Mountains, Australia

◄ 6x7 SLR, 45mm lens, 1/30 sec f11, Ektachrome 50STX, tripod

LIGHT DIRECTION

While light can strike a subject from any direction, landscape photographers usually have just a single light source to contend with: the sun.

Lighting is determined by the angle of the sun and the position of the photographer relative to the sun and the subject. The commonest types of lighting encountered by the landscape photographer are top lighting, frontal lighting, side lighting and back lighting.

Top lighting occurs when the light source (usually the sun) is directly above the subject. We are pretty used to this type of light because we see it for long periods every day. Generally, landscape photographers try to avoid top lighting because it doesn't throw interesting shadows across the land. Texture and form are lost.

Frontal lighting is similar to top lighting in that few shadows are cast. Without appropriate shadows, it is difficult for the photograph to reveal the three-dimensional aspects of our subject.

Side lighting is similar to frontal lighting in that it travels parallel to the earth, rather than perpendicular to it as top lighting does. However, unlike frontal lighting, side lighting is excellent for revealing shape and form because of the shadows it casts. Because the light

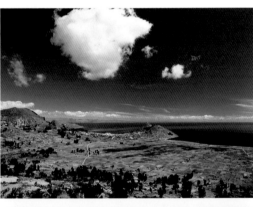

Lakeside town, Copacabana, Bolivia

It is midday and the sun is directly overhead. No shadows are thrown and the result is flat lighting with contrasting shadows under the trees.

◀ 35mm SLR, 20mm lens, f11, Kodachrome 64, tripod, top lighting

White tree, Twyfelfontein, Namibia

This pattern shot was taken with front lighting. There is very little shadow detail, except immediately behind the tree itself.

◀ 35mm SLR, 75-300mm lens, f8, Ektachrome 100, tripod, front lighting

crosses the subject, bits and pieces (such as trees in a landscape) cast shadows that can be seen by the camera. These shadows give us a clue to the subject's three-dimensional nature.

There can be all sorts of side lighting, depending on the angle that it crosses the subject. It can strike the subject at a 45°, 90° or 135° angle. It can also be higher without becoming top lighting. Each angle will throw a different shadow and it is up to the photographer to observe and record the most pleasing angle.

Back lighting occurs when the light is behind the subject. If the subject blocks the light, with the right exposure, a silhouette can be created. You can also achieve 'rim lighting', where the edges of the subject are highlighted by a bright fringe of light.

Back lighting can also be up higher, out of the image frame. This is sometimes called 'contra jour' or 'against the light'. You will always need a lens hood to shoot into the light, and care needs to be taken with the exposure, but contra-jour photos can be very luminous and striking.

If the light is hitting your subject in the wrong place, you have several options: move the subject (not usually an option with landscapes), move yourself, wait, or return at the appropriate time of day.

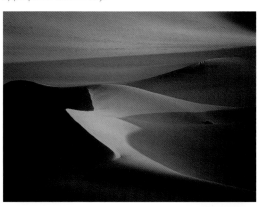

Sand dune, Sesrium, Namibia

This beautiful light show at sunrise lasted only a few fleeting minutes, but long enough to fire off a roll of film. You can clearly see the effect of the side lighting at it skims across the dunes, allowing for detail on one side and deep shadow on the other.

◀ 35mm SLR, 300mm lens, f16, Ektachrome 100, tripod, side lighting

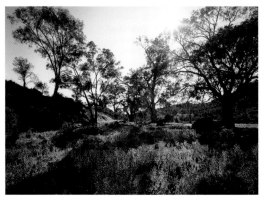

Paterson's curse, Flinders Ranges, Australia

This is a classic back lighting situation. The trees are silhouetted, while the flowers in the foreground are glowing. By positioning the sun behind a branch, flare is minimised.

◀ 4 x 5in large-format camera, 90mm lens, f22, Ektachrome 100, tripod, back lighting

LIGHT QUALITY

The quality of the light during twilight is completely different from direct sunlight. Shadows are very soft, meaning there is a gradual blending from light to shade rather than a distinct dividing line. Without heavy shadows, detail in all areas of a landscape is clearly visible.

Direct sunlight, on the other hand, is much stronger. Subjects look more powerful and angular, and shadows are distinct and definite. It is not forgiving like a soft light source.

The difference in light quality is related to the size of the light source relative to the subject. Although the sun is a huge light, from the Earth it appears as a small point of very intense illumination. Light waves reaching a subject from the sun are travelling parallel to one another, and this is why shadows are so sharp.

Compare this situation with twilight when the entire sky becomes your light source. The sky is huge, and light waves reach your subject from all directions. If there is a slightly stronger light source from the west, any shadows it throws are 'filled in' by the weaker light coming from the other directions.

Naturally, the weather has a big impact on the quality of light. Sunny weather means direct sunlight, rainy weather means softer light through clouds – and of course there's a host of variations in between. Overcast days work like twilight. The cloud cover converts the sun's small point of light into a larger light source, providing a much softer illumination. It also reduces the intensity of the light and changes the colour from neutral to blue.

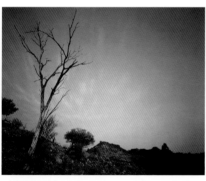

Dead tree, Australia

The presence of a great deal of volcanic ash in the atmosphere created a wonderful afterglow during twilight for several months by scattering and softening the light.

◀ 4 x 5in large-format camera, 65mm lens, 8 secs f8, Velvia, tripod

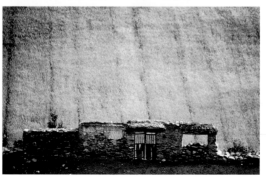

Farm wall, Cuzco, Peru

With a light cloud cover, the sunlight is diffused so that even in the middle of the day there is some soft, flattering light to work with.

◀ 35mm SLR, 100-300mm lens, f8, Kodachrome 64, tripod

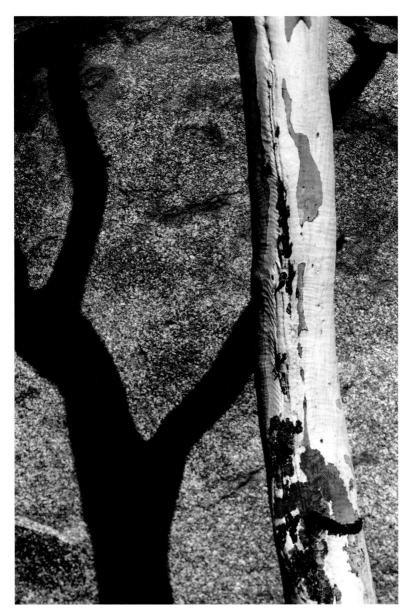

Gum tree, Devil's Marbles, Australia

Direct sunlight can sometimes be controlled with the right exposure and subject matter. Here, the sharply defined shadows cast by the tree clearly describe the directionality of sunlight.

▲ 4 x 5in large-format camera, 135mm lens, f11, Velvia, tripod

COLOUR TEMPERATURE

Although we perceive light as being white or neutral, we know that sunlight changes colour around sunset. Light is also a different colour in shade and when it's cloudy. This difference in the colour of light is described as colour temperature.

White light is made up of a number of coloured wavelengths, but this mixture varies according to the proportions of each colour emitted by the light source and reaching the subject. Tungsten bulbs found in the home, for instance, give out more red and less blue than sunlight.

In order to classify the colours of light, scientists have devised a method of awarding each mixture of coloured wavelengths a colour-temperature value. They have done this by basing the measurements on a piece of metal heated until it glows and emits light. As the temperature increases, the wavelengths of light emitted from the metal change, beginning with deep red, turning to orange, then yellow and on through the spectrum to a bluish/white light. As each light change takes place, the temperature is noted and awarded to that particular colour in kelvins (K; the kelvin is a measure of temperature like Celsius and Fahrenheit). Absolute zero (zero kelvin) equals -276°C. At 5500K, light is considered neutral or white.

Usually a spot of confusion creeps in at this point because reds are commonly referred to as 'warm' although in terms of the colour-temperature scale they are actually colder than blues and greens! Warm light has a low colour temperature, while a cold light has a high colour temperature.

Tungsten lights and sunsets have colour temperatures around 3000K to 4000K. On overcast days and during twilight, the light has a higher colour temperature and looks blue, from 6500K to 12,000K.

Most film is daylight balanced, meaning it is designed to correctly record colours in midday sunlight at 5500K. If the colour of the light is not 5500K, you end up with a colour cast – the photo will look a little yellow or orange (as at sunset), or a little blue (as when overcast or in shade).

The image sensor in digital cameras can be set to any number of colour temperatures using the white-balance control. Most digital cameras adjust the white-balance setting automatically, choosing one of seven or eight pre-sets (such as daylight, overcast, shade, tungsten, fluorescent etc). More advanced digital cameras and most DSLRs have the same pre-sets, but also allow you to set specific colour-temperature settings. This is useful for photographers wishing to print directly from their camera, but if you are 'processing' your digital files on your computer you can usually apply colour-temperature adjustments later on.

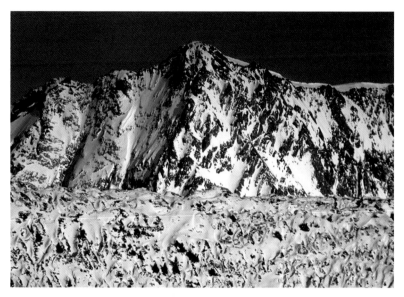

The Alps, France

These three images were taken over a period of an hour or so. The top image is front lit, with a relatively neutral colour balance.

When a cloud crossed the sun, the colour temperature rose and the colour of the snow turned blue.

Later, the sun set and the colour temperature cooled up dramatically.

All images created using 35mm SLR, 100-400mm lens, f8, Velvia, tripod

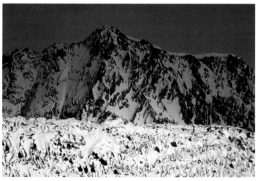

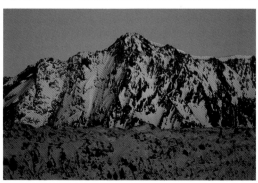

TIME OF DAY

It's often suggested that photographers should put their cameras away between 10am and 3pm because of the top lighting found during the middle of the day. The sun is too strong, throws harsh shadows and is far from flattering.

Midday lighting has another feature: its colour. It is said to be 'neutral' in that the light doesn't have a colour cast and is white. At sunrise and sunset the light is warm in colour with lots of yellows, oranges and reds. Subconsciously, humans respond favourably to warm colours and so the warm tinge in the early mornings and late afternoons gives

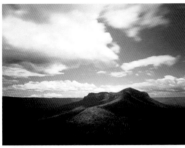

Katoomba, Blue Mountains, Australia

The middle of the day isn't the best time of day for landscape photography, especially in full sunshine, when the light is contrasting and neutral in colour.

◀ 4 x 5in large-format camera, 65mm lens, f32, ND filter, Velvia, tripod

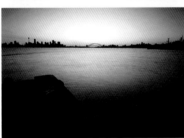

City skyline, Sydney, Australia

After the sun has set, sunlight can bounce off the atmosphere above and throw a beautiful glow over everything. Sometimes the best view is looking away from the sunset; on other occasions shooting into the light works well.

◀ 4 x 5in large-format camera, 65mm lens, f32, Velvia, tripod

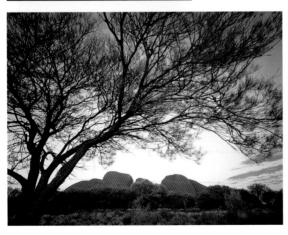

Sunrise, Kata Tjuta, Australia

At sunrise and sunset the colour of light takes on a warm tinge that can transform the mundane into the wonderful. Landscape photographers love these times of day.

◀ 4 x 5in large-format camera, 65mm lens, f32, graduated ND filter, Velvia, tripod

colour photographs a little lift. By simply turning around at sunset (or sunrise) so the sun is to one side or behind you, you're almost guaranteed award-winning lighting. The low angle of the sun throws long shadows, and the warm light records particularly well on film and digital sensors.

Although the colour of sunlight is reasonably neutral an hour after sunrise and up to an hour before sunset, its angle remains very useful. The side lighting throws shadows that give photographs a three-dimensional look. During winter months, three-quarter side lighting is often available even in the middle of the day because the sun doesn't travel directly overhead (depending on the latitude, of course).

Twilight is the period after the sun sets and before it is completely dark. It is also the period in the morning before the sun rises, when there is a silver glow in the air. On a clear night during twilight the entire sky becomes your light source. Twilight throws only very soft shadows. The light also has a cool colour to it and sometimes you can balance the blue light hitting one side of your subject with the warm afterglow of sunset striking the other.

If you mean to convey a distant or uneasy feeling, a heavy overcast sky could be just the ticket. Furthermore, in black-and-white photography, colour temperature is irrelevant to how the image is perceived and the overcast sky might add drama and excitement. Bad lighting conditions for colour photography can be perfect for monochrome.

FINE-TUNING THE LIGHT

The majority of great landscape photographs feature wonderful light, but even if you pick the perfect time of day and the perfect angle, sometimes a little more is needed.

This is where observation comes into play. By observing the surrounding landscape and estimating where the sun will be at another time of the day, or another time of year, you can return and create a masterpiece. For example, if a tree catches the last rays of light only during March when the sun peeps between two mountain peaks, a landscape photographer might come back for that perfectly lit photo. Admittedly, this is not a very practical approach for the travelling landscape photographer. Even if you can't hang around for days or weeks, it's still worth spending a little time observing your surroundings. Light can change dramatically as the sun rises and sets. Just being at a location with your camera for one or two hours can reveal a host of magic lighting effects as the sun catches the crest of a range or spotlights a tree against a dark background. It's easy to walk past these locations when the light is average and not give them a second thought. Landscape photography can be a bit like fishing, in that patience and perseverance are great assets.

Another opportunity for excellent light can be found at the beginning and end of a storm or weather change. While many landscapes have brilliant blue skies, postcard weather conditions can get pretty boring if that's all you photograph. When the weather changes, all sorts of atmospheric effects come into play and it is during these times that the light can look fantastic. However, these light conditions are often fleeting and if you're not ready to capture them, the photograph will be gone forever.

Landscape photography might seem to be something you can pursue at leisure, but when the light is changing there are often only seconds to play with.

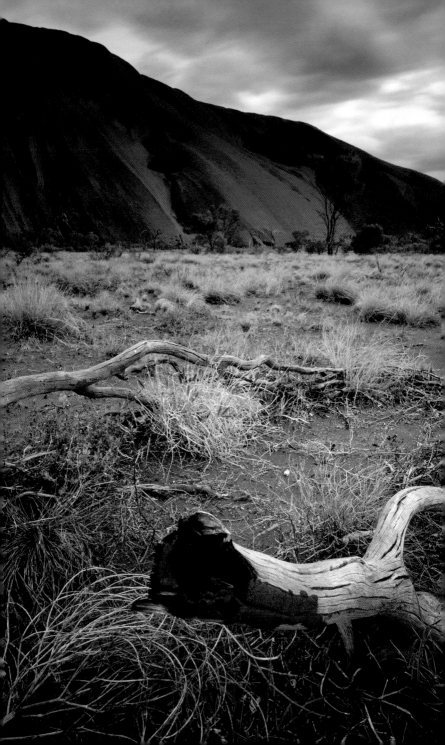

PART THREE :

Now that we've covered the basics – exposure, composition and lighting – it's time to apply them to some examples of landscape photography.

As you read through this chapter, stop for a few seconds to consider each photograph. Has the image been framed tightly or loosely? Are there distracting elements within the frame? Where has the centre of interest been positioned? Is the subject side lit, front lit or backlit?

The photos in this section are only examples and there are many other ways of shooting similar subjects. It's up to you to take what you like and develop your own style of landscape photography. Don't forget the golden rule: all rules are meant to be broken.

ON THE ROAD

Broken branches, Uluru-Kata Tjuta National Park, Australia
◀ 4 x 5in large-format camera, 65mm lens, 16 sec f32, Velvia, graduated ND filter, tripod

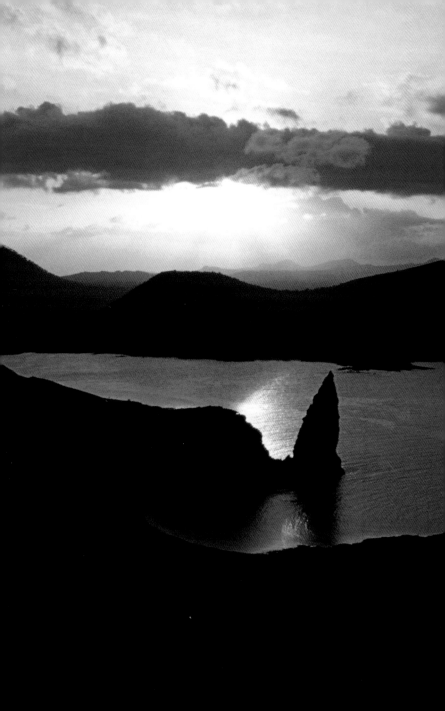

SUNRISE & SUNSET

Everyone takes sunrise and sunset photographs from time to time. It's almost an initiation rite on the path to becoming a photographer!

There's not much skill required to take sunset photographs. Generally, all you need to do is point your camera in its general direction and you'll get something that is bright and colourful. And your viewers will love these photographs.

When you succumb to the need to take sunset photographs, try to include something interesting in the foreground or middle ground. Generally speaking, the foreground or middle ground will be a silhouette, because the sunset or sunrise itself will be much brighter, and you'll be pointing your camera directly into the sun.

If you include the sun in the photo, sunlight will directly enter your lens. It can bounce around inside a bit and create flares and haloes. There's not much you can do about this, although the effect can be altered depending on the aperture selected (a smaller aperture will produce a smaller flare).

If in doubt about your exposure, try underexposing by one or two stops as you will get better colour saturation. If in doubt, bracket.

Finally, rather than photographing the sunset itself, turn around and see what's happening elsewhere. It's the light from the sunset that makes great landscape photographs, rather than the sunset itself.

Sun on horizon, Etosha Wildlife Reserve, Namibia

With lots of dust in the air over the desert, the sun turned into a brilliant red ball just prior to setting. I ran up to the top of a lookout tower, but without a tripod, so this shot was taken with my lens resting on a railing. Several exposures were made as the sun disappeared.

◀ 35mm SLR, 300mm lens, f8, Ektachrome

Sunset afterglow, Snowy Mountains, Australia

If you miss the sunset, don't worry. Very often there is a second display during twilight called the afterglow. It requires a tripod, and while it mightn't look fantastic to the naked eye, the display can be rendered very colourfully on film (due to reciprocity failure, which occurs when colour shifts during long exposures).

◀ 35mm SLR, 100-300mm lens, f5.6, Ektachrome, tripod

Sullivan Bay and Pinnacle Rock at sunset, San Salvador Island, Galápagos, Ecuador
◀ 35mm SLR, 100mm lens, 1/4 sec f16, Ektachrome E100VS, tripod

SKIES

Many landscape photographers wait for clear blue skies, but with cloudless skies landscapes quickly become boring. It's much better to mix up your scenes with a variety of skies. Indeed, an amazing sky can become the subject of your photograph, with the landscape included purely to give the photograph a sense of balance.

Most sky photographs have the horizon positioned very low in the frame, and some will even exclude it. And with digital post-production techniques that allow us to combine photographs, it's always useful to build up a library of interesting skies to replace boring ones.

Generally your camera will read the exposure correctly, but the small strip of landscape at the bottom (if you have included it) may appear dark and underexposed. This isn't a problem if the sky is the main subject. In fact, underexposing the sky by half or one stop can add colour saturation and detail, especially if the image includes white clouds.

The following tips will improve your photos of the sky:

▶ choose a wide-angle lens so that you can include a broad expanse of sky
▶ use a polarising filter to increase the contrast between the clouds and the sky and to enhance the blues
▶ shoot just before and after storms and during other changes in the weather.

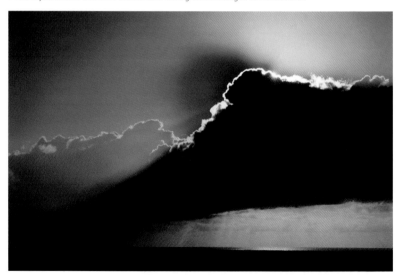

Storm cloud, Easter Island, Chile
Thousands of miles from anywhere, Easter Island is a fascinating destination even without its stone statues. This cloud formation presented itself to me one afternoon as I was walking along the island's coast.

▲ 35mm SLR, 28-135mm lens, f8, Ektachrome 100

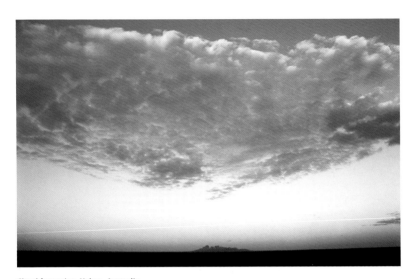

Cloud formation, Yulara, Australia

In the pre-dawn light only the very top clouds are reflecting sunlight, while the rest of the scene is bathed in blue sky light. An ultra wide-angle lens and a low horizon give the image plenty of space, and there is a subtle repetition of shapes with the clouds reflecting the rock formations below.

▲ 35mm SLR, 20mm lens, f2.8, Velvia, tripod

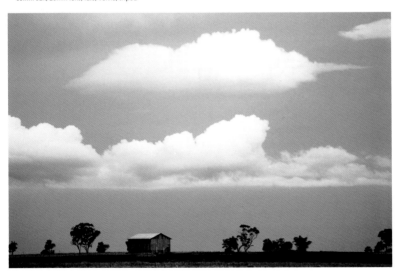

Storm clouds, Armidale, Australia

I find that your chances of encountering changes in weather increase when driving long distances and this is exactly how I found this scene. The sky was fantastic, but it was difficult to find a suitable landscape, so I simply concentrated on the sky.

▲ 35mm SLR, 100-300mm lens, f5.6, Ektachrome 100, tripod

STORMS & BAD WEATHER

Don't put your camera away when the weather changes. This is often the time when the light is superb. Storms and bad weather can produce exciting opportunities, but you have to be ready for them. A burst of sunlight might last for only a few seconds, and if you don't have your camera at the ready, the opportunity will be lost.

During torrential rain and heavy mist, visibility is significantly reduced and you will need to concentrate on nearby vistas. The colour can also appear a little dull or lifeless, so choose a high-contrast, high-colour film (such as Fujichrome Velvia or Kodak ExtraColor), or, if shooting digitally, increase the contrast and colour saturation during post-production.

As the bad weather clears, more opportunities often arise with increased visibility and the chance of breaking sunlight.

When photographing in bad weather:

▶ take an umbrella; this will protect you and your camera during rain

▶ keep a plastic bag or two to keep equipment and film dry

▶ use a wide-angle lens; this will allow you to include the sky, which is often the best part of a stormy landscape.

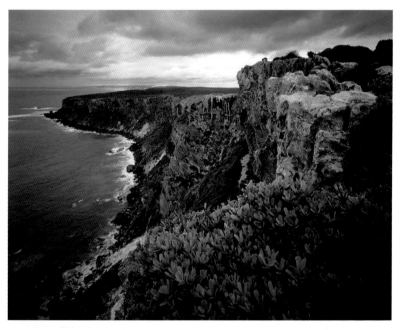

Precarious growth, Cape Leeuwin, Australia

While the sky was stormy and overcast a dramatic and colourful composition was created by positioning the camera down low and close to the cliffside vegetation. A graduated neutral density filter was used to darken the sky.

▲ 4 x 5in large-format camera, 65mm lens, 1/4 f32, Velvia, graduated ND filter, tripod

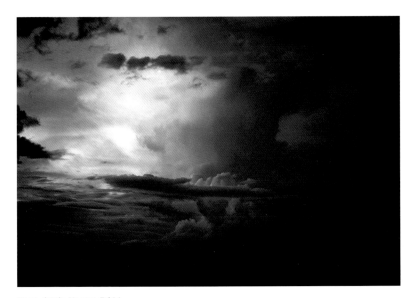

Storm clouds, Moorea, Tahiti

The tropics have fantastic storm clouds. This image was taken late one afternoon and was slightly underexposed to produce more detail in the clouds and to give the colours more saturation.

▲ 35mm SLR, 20mm lens, f2.8, Velvia, tripod

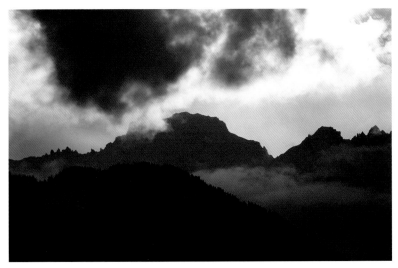

Mountain peaks, Verbier, Switzerland

Travellers can often capture great views from their hotel windows. This view fascinated me for two weeks, changing with the time of day and particularly the weather. Although they look stormy, these clouds quickly passed by.

▲ 35mm SLR, 100-300mm lens, f5.6, Velvia, tripod

RAINBOWS

Rainbows can be tricky to photograph. They look wonderful to the naked eye, but when recorded on film or by a digital sensor they can easily lose their colour and impact.

Another challenge is to find a rainbow when there's something worth photographing underneath it! Rainbows are exciting to photograph, but unless the surrounding landscape is equally exciting, the photograph will have limited appeal.

Fortunately, rainbows don't only occur when it's raining. You can find them anywhere water is suspended in air, such as in the spray from a breaking wave on the shore or in a waterfall. A dark background (dark clouds or rocks) will help the rainbow stand out, and the more rainbow there is (water in the air to refract the light), the better.

A polarising filter can be useful for enhancing the rainbow's colours. To slightly saturate the colours, underexpose the image.

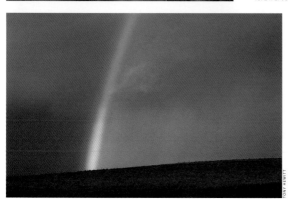

**Moran's Falls,
O'Reilly's Guesthouse, Australia**

Due to the small amount of water suspended, this rainbow is more of a subtle accent than a fully fledged bow.

◀ DSLR, 100-400mm lens, f5.6, ISO 100 ,
4072 x 2708, RAW, tripod

**Rainbow, Pemberton,
Australia**

A little bit of digital enhancement (darkening of the sky and increasing the colour saturation in the rainbow) has produced an image that is closer to the memory of the rainbow than what the film recorded.

◀ 35mm SLR, 80-200mm lens,
f4, Velvia

TONY HEWITT

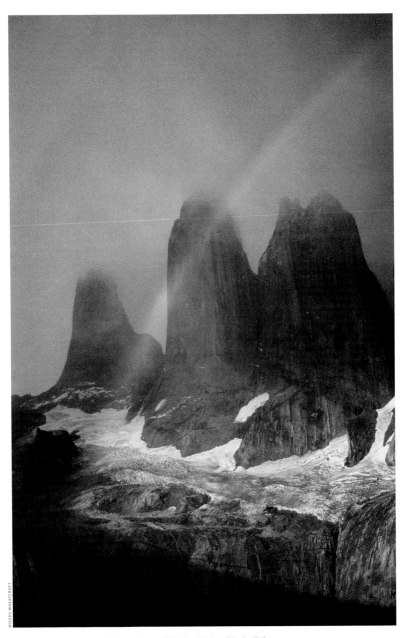

Rainbow over the Towers of Paine, Torres del Paine National Park, Chile

▲ 35mm SLR, 24mm lens, 1/250sec f3.5, Fuji Provia

LIGHTNING

Some people consider photographs of lightning to be the result of sheer luck, but there are photographers who are dedicated to capturing this difficult subject. They will spend hours, if not entire nights, following storms and waiting for the perfect bolt from the heavens. If anything, they make their own luck and increase their chances by being persistent.

The technique used to capture lightning isn't particularly difficult: set up your tripod, point your camera in the direction you expect lightning to strike and then open the shutter. Exposures can vary from several seconds to many minutes or hours, depending on what other light is present (twilight, moonlight, street lights). All the other aspects of good landscape photography come into play – lens choice, composition and timing. Wide-angle lenses are often used because it isn't possible to predict where the lightning will strike with pinpoint accuracy.

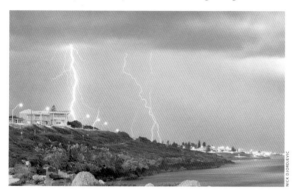

Marmion, Australia

It's easiest to shoot lightning at night because you can set up your camera for long exposures of several seconds or minutes, during which time you pray there will be one or two lightning strikes.

◀ 35mm SLR, 80mm lens, 20 secs, tripod

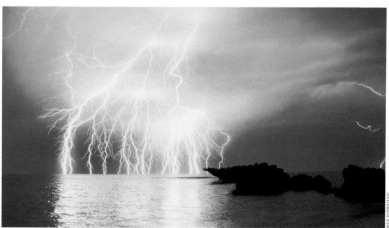

Ten billion volts, Trigg, Australia

Weather forecasts and some background knowledge of storms are useful for shooting lightning, but it's mostly a matter of being there at the right time and taking advantage of what nature provides.

▲ 35mm SLR, 28mm lens, 30 mins, tripod.

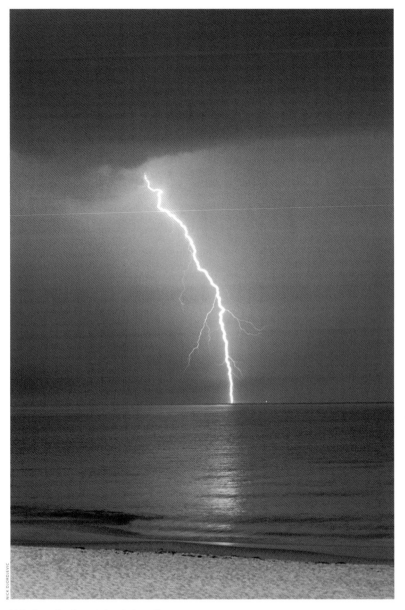

NICK DJORDJEVIC

Lightning strike, Sorrento beach, Australia

Street and house lights behind the camera have illuminated the sand in the foreground, while the lightning bolt has lit up the storm clouds.

▲ 35mm SLR, 35mm lens, 5 mins, tripod.

MIST & FOG

One of the easiest ways to produce a striking photograph is to be up early on a foggy or misty morning. Fog and mist probably have less appeal for people who deal with it regularly compared to those who see it only rarely. Fog and mist can reduce your scene to its most important elements and hide distracting backgrounds.

When you're in the thick of fog or mist, subjects are quite close by because visibility is usually limited to only a few metres. The light can be flat and uninteresting, but when the fog or mist lifts and the sun reaches through, the light turns magical.

Photographing fog from a distance can also produce spectacular results, especially in hilly or mountainous terrain. You need a vantage point that is fog free, or visit a location that you know photographs well and wait for the fog or mist to lift.

Vineyards in mist, San Gimignano, Italy

This image was taken before sunrise from a dirt road underneath the ancient walls of San Gimignano in Tuscany. The scene is recorded faithfully, but image-editing software has been used to warm up the colours in the foreground and cool them in the background. The edges have also been darkened for effect.

▼ DSLR, 17-35mm lens, 1 sec f2.8, ISO 100, 4072 x 2708, RAW, tripod

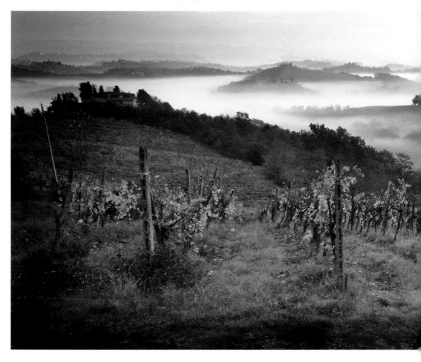

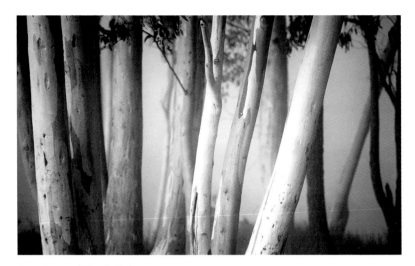

Gums, Kangaroo Valley, Australia

This stand of gums was outside my bedroom window at a friend's country property. I loved the luminous quality of the tree trunks which were being lit by wan sunlight as the mist lifted. Within five minutes the mist was gone.

▲ 35mm SLR, 28-135mm lens, f4.5, Kodachrome 64, tripod

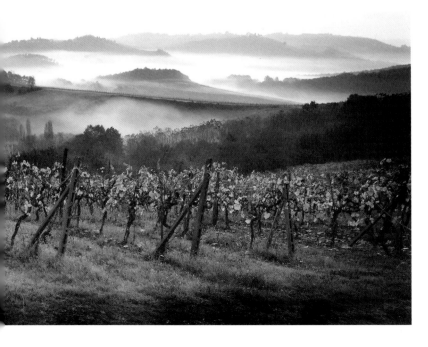

RAIN

Photographing in the rain is annoying because you get wet, but if you can find a little shelter or you can photograph the rain from a distance, the results can be both distinctive and appealing.

Photographing in or just after rain sometimes produces beautiful colours. When wet, branches, leaves, flowers and rocks seem to shimmer with colour, and the soft light is ideal for close-ups. At greater distances, the grey of the clouds and the mantle the rain puts across the landscape creates more muted colours. This subtleness can also produce beautiful, moody images.

When photographing in the rain, note that:

▸ an umbrella will protect you and your camera

▸ a tripod can be useful to prevent camera shake, since there isn't much light

▸ a small aperture will maximise depth of field and keep more of your subject in focus if you're taking close-ups.

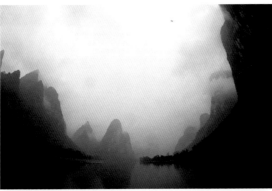

Li River, Guilin, China

Our river cruise was not looking promising, with heavy clouds and intermittent rain, but when the ferry passed below some steep peaks, a moody, brooding landscape appeared. The photo was taken with a fish-eye lens, which accentuated the peaks. Some rain drops are visible in the sky, making the image more real.

◀ 35mm SLR, 16mm fish-eye lens, f5.6, Velvia

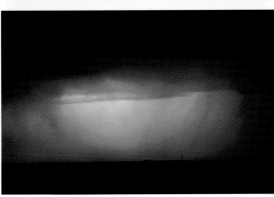

Rain squall at sunset, Birdsville, Australia

After a really hot, windy and unpleasant day at the Birdsville Races in outback Queensland, a series of short storms marched across the desert. The last one happened around sunset, so I ran out of town to get a clear horizon line and snapped a couple of colourful images.

◀ 35mm SLR, 28-135mm lens, f4.5, Velvia

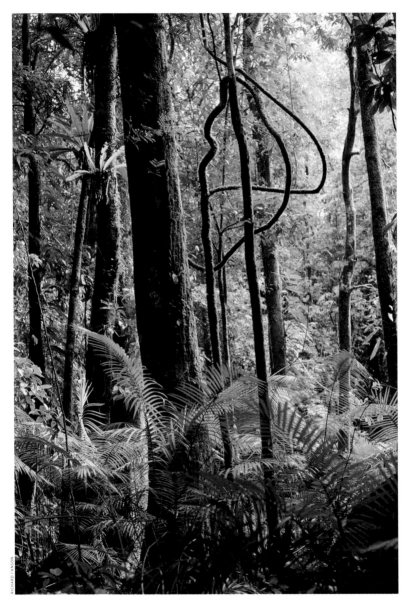

Rainforest in Mossman Gorge, Daintree, Australia

The ideal time to photograph in rainforests is after it has rained, or in light drizzle. The cloudy skies guarantee an even light and the water on the leaves adds life and emphasises the colour. A polariser is useful to cut down reflections.

▲ 6 x 7 SLR, 45mm lens, 1/4 sec f16, Ektachrome 50STX, polarising filter, tripod

SNOW

You may have heard that it is difficult to photograph in the snow, but this isn't really the case. The main issue is the brilliance of the snow fooling the camera's light meter, resulting in snow that is grey rather than white.

There are several ways around exposure problems when shooting snow:

▸ Bracket your exposures or simply take an additional exposure at plus one stop.

▸ Use the spot-meter function in your camera, meter the snow and then add two or three stops to your exposure (depending on how white you want the snow to look).

▸ Use the spot-meter function in your camera and meter off a mid-tone subject in the scene.

▸ Use a digital camera and check the histogram on the LCD screen to ensure the exposure is correct.

With experience, exposure won't be a problem, especially if you're shooting colour negative film or digitally, as exposure latitude will cover up most of your sins.

There are plenty of opportunities with snow, from delicate close-ups of snow-clad bushes to frozen expanses with crystal blue skies. Colour temperature also has a big impact. Sky light produces cool blues, and in the middle of the day the sky itself can be an inky black, especially if you use a polarising filter. Later in the day, the setting sun and the afterglow can produce beautiful pinks and oranges.

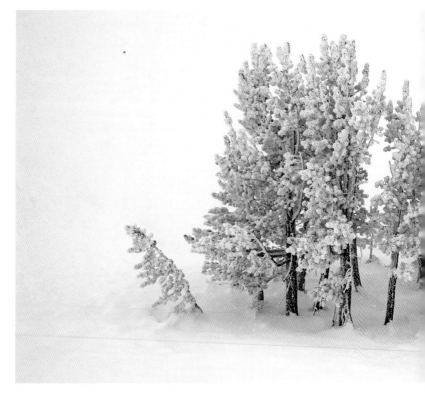

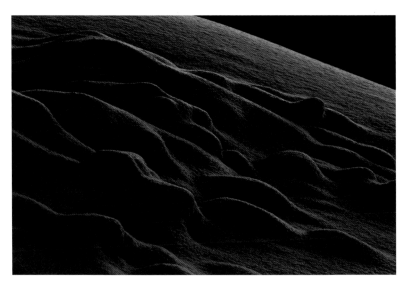

Snow textures, Verbier, Switzerland

Freshly fallen snow looks absolutely wonderful, especially before it is affected by wind or sun. This detail shot was taken from my apartment window – it's amazing what you can find with a telephoto lens.

▲ 35mm SLR, 100-400mm lens, f5.6, Velvia, tripod

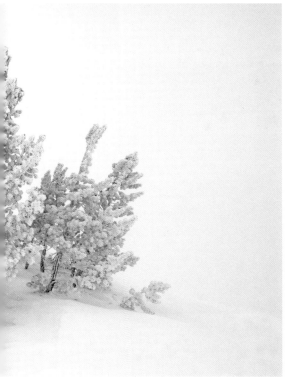

Snow-covered bushes, Mammoth Mountain, USA

While I was on a job for a skiing magazine, the weather turned poor for action but excellent for photographing this small stand of trees. Light snow was falling, plastering the leaves with a fine covering of ice crystals.

◀ DSLR, 16-35mm lens at 28mm, 1/2000 f5.6, ISO 100, 4072 x 2708, RAW

MOUNTAINS

When we're impressed by the sheer size of the mountains in front of us, it's tempting to use a wide-angle lens to fit it all in, but the majesty can be lost. A telephoto lens is often the best choice for photographing mountains; it will allow you to pick out small sections of mountain that might otherwise go unnoticed. Mountains can also make great backdrops for other subjects, especially if you exclude the sky from your composition.

Weather plays an important role in mountain photography. If you get an opportunity to shoot a mountain, never put it off till later in the day or the next day, because chances are it won't look as good. Special light in the mountains is fleeting.

For better mountain photos remember to:
▶ use a tripod (mountains don't run away)
▶ use an ultraviolet or skylight filter if shooting mountains in the distance; this will cut the haze
▶ use a telephoto lens to zoom in and look for abstract compositions.

Sassolungo, Campitello, Italy

Putting the rubbish out late one evening I glanced up and this is what I saw. Using a telephoto lens to zoom in on the main subject resulted in a stronger composition; the entire view taken with a wide-angle lens would not have been so impressive.

▶ DSLR, 105mm lens, 1/320 f8, ISO 100, 4072 x 2708, RAW, tripod

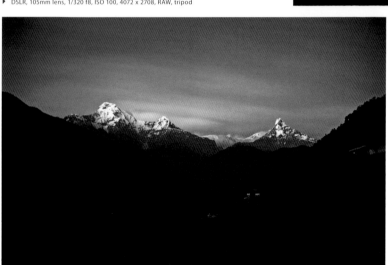

Machhapuchare and the Annapurnas, Nepal

It was an hour after sunset on a beautiful clear evening and the snow on the peaks was still reflecting light. The long 30-second exposure in combination with reciprocity failure produced the magenta colour shift in the foreground.

▲ 35mm SLR, 20mm lens, 30 secs f2.8, Kodachrome 64, tripod

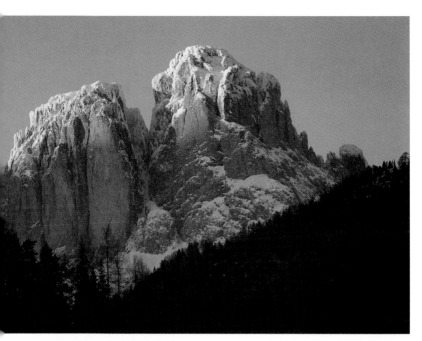

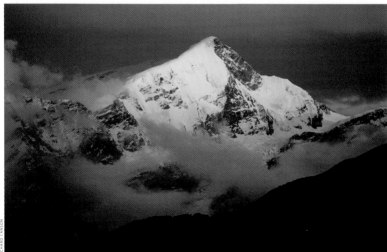

Sunset on Mt Trisul, Kuari Pass, India

The sight of a big mountain glowing in the warm colours of sunset is a great reward for a long climb up a steep hill. But remember, the colours are often fleeting and you need to be well organised and prepared, creatively and technically, to capture the image when the colours are at their most intense.

▲ 35mm SLR, 50mm lens, 1/8 sec f16, Ektachrome E100VS, tripod

DESERTS

Deserts are wonderful places. The sense of space is spectacular, and while we think of deserts as being sandy, there are many different types of desert to explore and many have more vegetation and variety than you might expect.

A wide-angle lens is essential for deserts so you can accentuate the space. A panoramic camera also works really well (although you can simply crop photographs taken with a 35mm SLR to achieve similar framing). If you're planning a visit, be sure you're there before sunrise and after sunset. You can have a sleep in the middle of the day if necessary!

The following pointers are worth remembering when in the desert:

▶ Side lighting will bring out lots of texture in the foreground.
▶ Small apertures and the use of hyperfocal focusing will maximise depth of field.
▶ When in sandy deserts, keep your equipment out of the sand or you might find it doesn't work again. Be careful when you put your camera bag down in the sand and open the lid – watch when you close it that you don't throw sand over the bag's contents.
▶ If you're in a hot desert, keep your film cool during the middle of the day by wrapping it in clothes or using a cool box.
▶ Digital cameras should work fine, but the heat can cause noise, so don't leave your camera sitting in the sun unnecessarily.

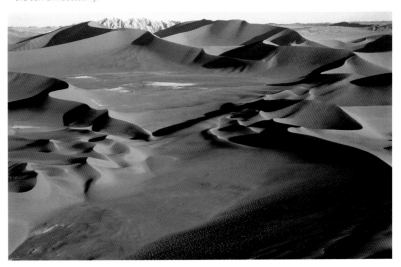

Namib Desert from the air, Namibia

We convinced our pilot to remove the door, giving us uninterrupted views of the desert below. Even though taken from the air, this image uses the foreground, middle ground and background approach to composition, while late-afternoon side lighting creates a strong, three-dimensional effect.

▲ 35mm SLR, 28-135mm lens, f5.6, Velvia

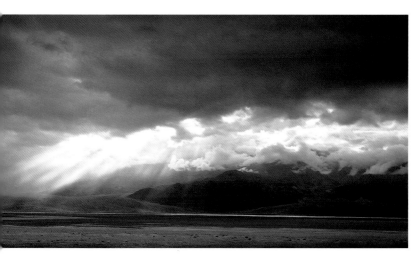

Sunburst, Death Valley, USA

Driving frantically to Badwater to catch the last rays of light, I was torn between stopping for this light show and thinking about what might be at the other end. I decided a bird in the hand was worth two in the bush.

▲ DSLR, 35mm lens, f10, ISO 100, 4072 x 2708, RAW, tripod

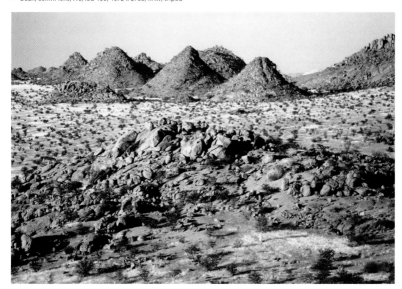

Stony desert, Twyfelfontein, Namibia

If you don't like the landscape in Namibia, drive for half an hour and it will change dramatically. North of the Namib Desert sand dunes is a rugged, rock-encrusted land. Although the rock and grass were already warm in colour, the effect was accentuated with a warm-balanced film. A similar effect could be reproduced with a warming filter or with digital post-production.

▲ 35mm SLR, 28-135mm lens, f8 aperture-priority, Ektachrome 100SW, tripod

THE COAST

Changing weather and sea conditions make the coast an exciting place to photograph. Because the sea is always in motion, you're unlikely to get two photos the same. While the same rules of composition apply to both land and sea, make sure your horizons are level, because a sloping sea looks very awkward.

Long shutter speeds will blur the movement of the water and waves, and this contrasts nicely against clear, sharp rocks and sand. And at sunrise and sunset the water will reflect the colours of the sky, adding a further dimension to your seascapes.

When at the coast, remember to:

▶ Watch for sea spray, especially on windy days; it can coat your lens and also harm your camera.
▶ Use a tripod, as it will let you set long shutter speeds that create beautiful blurs in the sea.
▶ Never turn your back on the ocean – the next wave could be twice as big as the last.

Twelve Apostles, Port Campbell, Australia

One of Australia's most popular tourist spots, the Twelve Apostles are surrounded by walkways and 'Keep Out' signs, but with care you can still compose an image that shows none of this. In winter the sun sets behind the Apostles, producing a striking silhouette. The colour has been enhanced in post-production.

▶ DSLR, 16-35mm lens, f22, ISO 100, 4072 x 2708, RAW, tripod

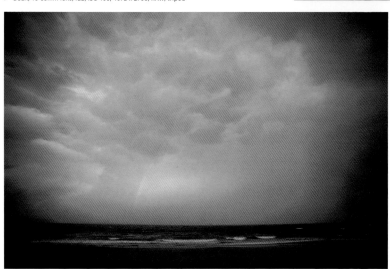

Afternoon Storm, Collaroy Beach, Australia

Working in an office overlooking the ocean has its advantages. When this light show erupted outside my window, I grabbed my camera and ran – the only thing I was missing was a tripod which would have made my life easier.

▲ 35mm SLR, 14mm lens, f4.5, Velvia

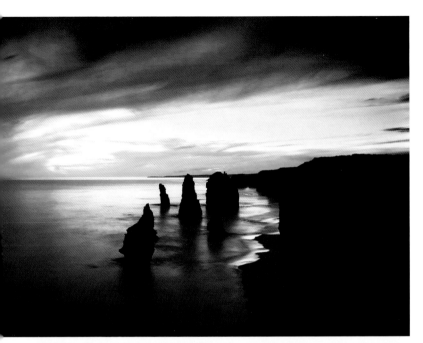

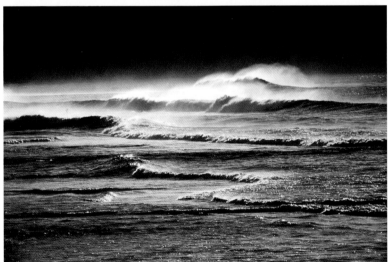

North Curl Curl, Australia

From one end of the beach, the view includes the northern headland as a backdrop (the dark area). As the waves break, an offshore wind throws plumes of water behind, which in turn are backlit by the sun.

▲ 35mm SLR, 200mm lens, f5.6, Kodachrome, tripod

FORESTS

Photographing in forests and rainforests is a challenge. Sunlight reaching into the forest creates areas so much brighter than the surrounding shadows that neither film nor digital cameras can handle the contrast range.

For this reason, the best forest photos are taken either on overcast days when the sunlight is filtered and softened through layers of cloud, or in the shadows of valleys and hills which are only illuminated by skylight. Under these circumstances direct sunlight doesn't affect the image, so the contrast is manageable, even though you might find a tripod is needed. To obtain a lot of depth of field, shutter speeds can run into several seconds with a stopped down aperture.

The light in the rainforest can be quite cool and green in colour, and the result on film can look woeful. Solutions include using a warming filter or a highly saturated colour film that handles greens well. Or you can use both.

In the forest, it can be difficult to find a clear view that allows you to capture the essence of your location. Look for breaks in the forest, such as rivers and glades, which provide a clear view, or shoot from the edge of the forest looking in. The other option is to shoot closer views and texture photos – tree trunks can produce great textures.

And don't forget to look up. There are some wonderful abstract patterns up in the canopy.

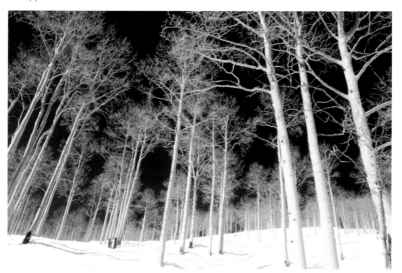

Trees, Steamboat Springs, USA

This is a classic example of what happens at high altitudes with a polarising filter – a clear sky can be turned almost jet black. The sky is already very saturated at this altitude, so a polarising filter isn't generally recommended, due to the increased contrast.

▲ 35mm SLR, 50mm lens, f5.6, Ektachrome 100, polarising filter

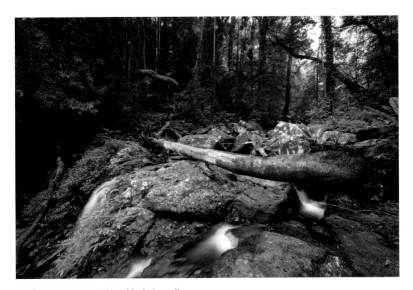

Rainforest, Lamington National Park, Australia

Tucked deep in a valley and hidden at the time from direct sunlight, it was a challenge to find any order in this chaotic scene. A fallen tree produced a diagonal line across the stream, giving a sense of direction. The bright sunlight in the top right corner has been darkened in post-production.

▲ DSLR, 16-35mm lens, f22, ISO 100, 4072 x 2708, RAW, tripod

Tree bark, Yosemite National Park, USA

When you can't find an overview, walk in close and focus on a small amount of detail. This pattern and texture shot was found by the side of a trail and, as it was evenly lit, was fairly straightforward to shoot.

▲ DSLR, 16-35mm lens, f22, ISO 100, 4072 x 2708, RAW, tripod

FLORA

Including flora within your landscapes can create a centre of interest, provide a splash (or even a flood) of colour, or be the basis of the landscape itself.

If the flowers and bushes are important elements in your subject, you will need to consider your shutter speed as well as your aperture. Even a light wind can have flowers waving wildly on the ends of their stems, so a shutter speed of 1/60 or even 1/250 may be needed to freeze their movement. Against this you have to consider your need for depth of field in the photograph. At an aperture of f22, you may find your corresponding shutter speed is too slow to freeze the action, so you will have to choose between lots of depth of field with blurred subjects, or less depth of field with sharp subjects.

Most flowers only bloom once or twice a year, often at reasonably predictable times. If you're really keen to photograph flora, ensure you're travelling in the right season.

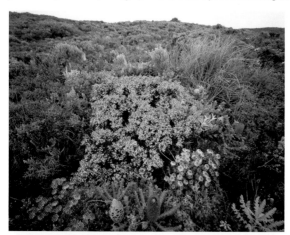

**Wildflowers,
Cape Leeuwin, Australia**

A wide-angle lens is angled downwards with just a thin sliver of sky at the top of the frame to give the location context. The overcast sky became a little thinner for a few minutes, which gave the colours some sparkle. A highly saturated colour film like Fujichrome Velvia also helped.

◀ 4 x 5in large-format camera, 65mm wide-angle lens, 1 sec f32, Velvia, tripod

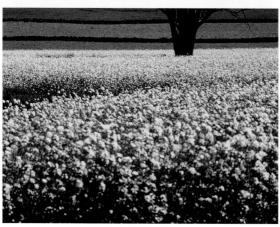

**Colours and patterns,
St Helens, Australia**

There are many crops with wonderful yellow flowers that can flood your landscape with a wash of vibrant colour. Sometimes a telephoto lens is useful for framing tightly, and introducing another element, such as a tree trunk, can provide a resting point for the eyes or a centre of interest for the composition.

◀ 35mm SLR, 24-70mm lens, 1/125 f11, Ektachrome E100VS, without lens hood

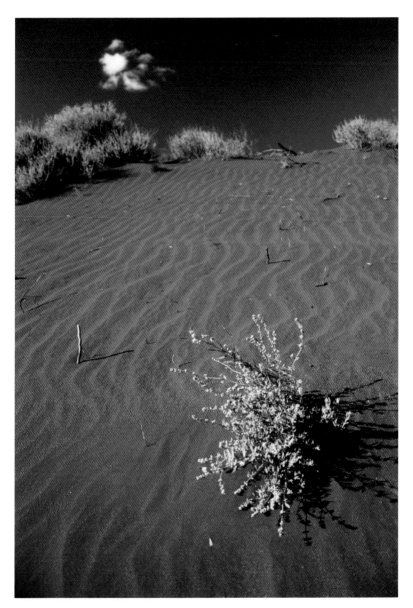

Desert flowers, Australia

The small cluster of flowers forms the centre of interest in this desert landscape. A polarising filter has been used to add colour saturation to the blue sky and red earth. You can see how the filter's edge has vignetted the corners in the bottom of the frame; this is a problem with many ultra wide-angle lenses when you use small apertures.

▲ 35mm SLR, 20mm lens, f22, Ektachrome

DETAILS

A detail photo is generally a close-up of a particular feature in a landscape – perhaps the texture of a tree trunk, or a group of rocks, or a combination of both. It could also be a single flower. In an album or an audiovisual presentation, a series of landscapes can be supplemented by a few detail photographs. Sometimes you can develop a theme of similar details from different locations – these can make an interesting series of images.

When shooting details, remember to:

▶ Frame or crop the image tightly so that only the details are included in the photograph.
▶ Consider your composition. Positioning tree trunks or rocks carefully in the frame can create a much more dynamic and interesting photograph than just leaving them in the middle of the photo.
▶ Watch your lighting. Often with details it's easy to change your standpoint so that you can photograph with interesting light falling across the subject.

A telephoto zoom lens is useful for framing, but not essential. If photographing at close distance, the depth of field will be shallower, so you many need to use a small aperture to compensate.

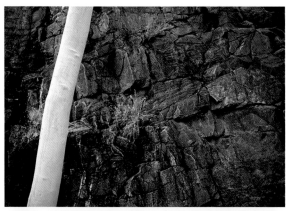

Tree trunk, Ormiston Gorge, Australia

The cool blues of the rock face contrast nicely against the warm pinks and browns in the tree trunk. Tight cropping has created an abstract image and the composition is made more interesting by positioning the tree trunk to one side.

◀ 35mm SLR, 28-135mm lens, f11, Velvia, tripod

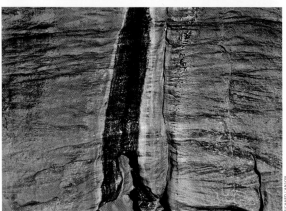

Rock detail, Blyde River Canyon, South Africa

A telephoto lens was used to isolate an interesting area of coloured rock on the steep walls of the canyon. By excluding the horizon and any other reference point the scale of the landscape can be hard to assess, adding another element of interest to the image.

◀ 35mm SLR, 180mm lens, 1/250 sec f5.6 Ektachrome E100VS, polarising filter

RICHARD I'ANSON

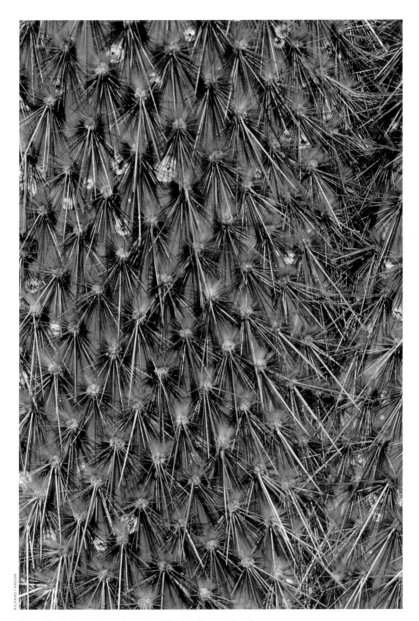

Cactus detail, Puerto Ayora, Santa Cruz Island, Galápagos, Ecuador

Cactuses feature in the landscape on many of the islands in the Galápagos, but it was still an exercise in patience and observation to find the perfect one for a frame filling detail to complement the wider shots of the landscape.

▲ 35mm SLR, 100mm lens, 1/125 sec f11 Ektachrome E100VS

RIVERS

Rivers are often featured as part of a larger landscape, but if you want to focus on the river itself, take advantage of its movement and use a long shutter speed. In this way the river becomes a bit like a waterfall, but instead of a stream of pure white, you can produce lovely blurs of green, blue and any other colour being reflected by the water.

If finding an overview is difficult (because of surrounding foliage), look at smaller landscapes. Close-ups can be a lot of fun to produce, especially with the added dimension of time-blurred water.

And if you're photographing in the desert, dry river beds can be great locations to explore. While long shutter speeds won't produce any noticeable blur, the line of the river itself can be used as a compositional tool.

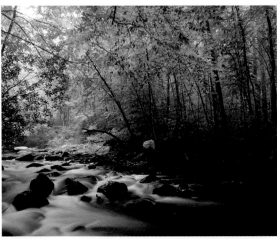

Stream in forest, Great Smoky Mountains National Park, USA

By filling the foreground with the stream it becomes the focal point of the landscape rather than the surrounding forest. The emphasis is further heightened by the use of a slow shutter speed to blur the water.

◄ 6 x 7cm SLR, 45mm lens, 1 sec f11, Ektachrome E100SW, tripod

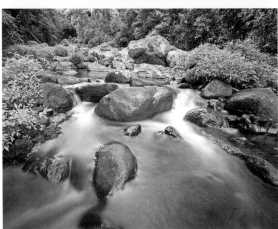

Elabana Falls, Lamington National Park, Australia

When we reached this area the light wasn't optimal, so I tried to make up for it with a strong composition. I used a very wide angle lens with a low viewpoint, and set the longest shutter speed possible to blur the water.

◄ DSLR, 17-35mm lens, f22, ISO 100, 4072 x 2708, RAW, tripod

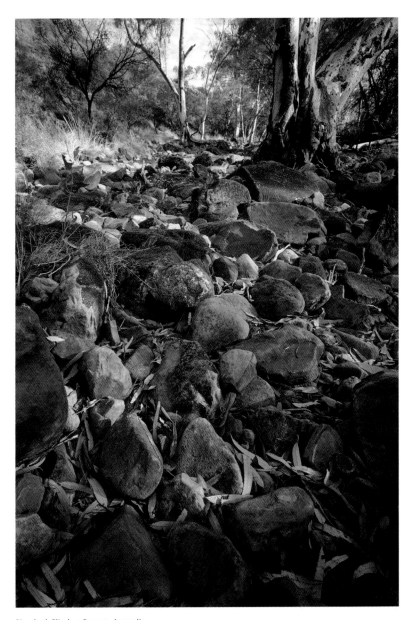

Riverbed, Flinders Ranges, Australia

A low viewpoint and the placement of the horizon high up in the frame focus attention on the rocks and leaves which form the bed of a dry river. Dappled sunlight mimics the busy foreground.

▲ 4 x 5in large-format camera, 65mm lens, 1 sec f32, Ektachrome, tripod

WATERFALLS

Like flowing rivers, waterfalls work especially well when you can blur the water. This isn't to say every waterfall shot you take should be blurred, but if you're wanting to create a photograph with a difference, this is a good starting point.

The surest way to get a blur is to use your smallest aperture setting – f16, f22 or f32, depending on your lens. You can also add a neutral density filter to reduce the amount of light reaching the film or sensor, thus requiring an even longer exposure. And the longer the exposure, the greater the blur.

Blur will begin around 1/15 of a second but makes itself really felt from 1/4 of a second onwards. Once you get into the seconds – up to 30 seconds – you create a really milky blur.

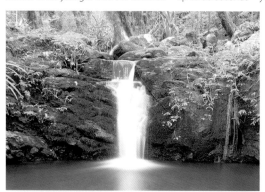

**Stairway Falls,
Lamington National Park**

When shooting waterfalls, the shutter speed is an issue. While 1/30 second or faster will more or less freeze the water, 1/15 and 1/8 second begin to show some blur. At one second and 30 seconds, the water takes on a milky look.

◀ DSLR, 16-35mm lens, 30 sec f22, 4072 x 2708, RAW, tripod

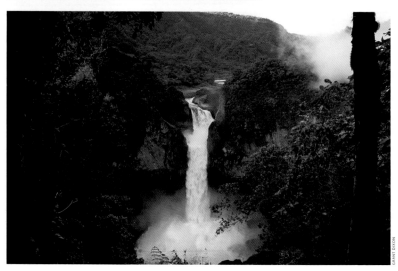

San Rafael Falls, Ecuador

▲ 35mm SLR, 28-70mm zoom lens, 1/4 sec f11 Fujichrome RDPIII, tripod

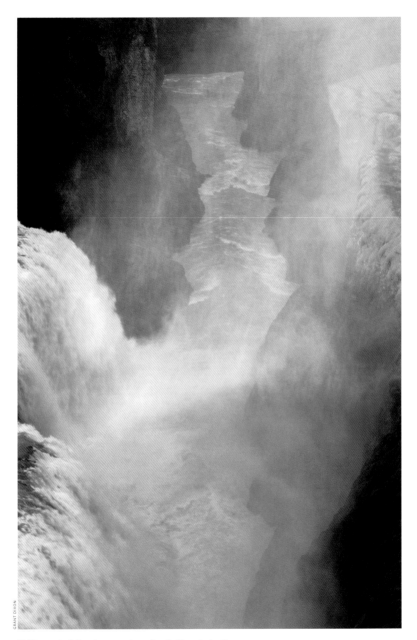

GRANT DIXON

Gullfoss waterfall and canyon at sunrise, Gullfoss, Iceland

▲ 35mm SLR, 20-35mm zoom lens, 1/15 sec f11, Fujichrome RDPIII, tripod

LAKES

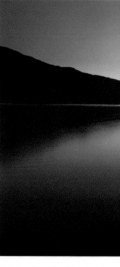

Whereas the sea is likely to be wild and full of movement, lakes are generally still, with little if any wave action, though a breeze may ruffle the water's surface. As many lakes are found in mountainous regions, you're likely to find some great reflections on a still day. When photographing lakes, horizon lines are often best positioned in the middle of the frame, as the surroundings reflected in the water can be as important as those above water. However, just because your horizon is centrally located, doesn't mean your subject has to be centred as well. Try to find a point of interest to one side to offset an otherwise static composition.

You'll find that early mornings and late afternoons are the best times for photographing lakes, but watch the shadows that form when the sun is near the horizon. Surrounding hills can throw shadows – either use these shadows as an integral part of your composition, or wait until the sun is gone completely and shoot in the twilight.

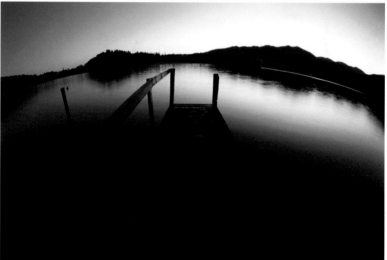

Jetty, Orta San Guilin, Italy

A fish-eye lens has created the curved horizon, while the twilight is just catching the yellow railing, but it is the reflection of the sky in the water that creates the interest in the image.

▲ 35mm SLR, 16mm fish-eye lens, f2.8, Ektachrome, tripod

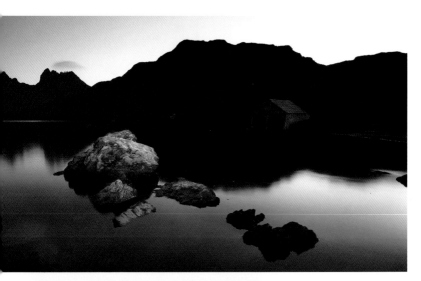

Dove Lake,
Cradle Mountain, Australia

Dove Lake is surrounded by mountains and is a picture-postcard location. However, once the sun goes down, most of the visitors leave and miss a great light show. A little bit of post-production has been done to de-saturate the image and add colour to the lone cloud above Cradle Mountain.

▲ DSLR, 16-35mm lens, f22, ISO 100, 4072 x 2708, RAW, tripod

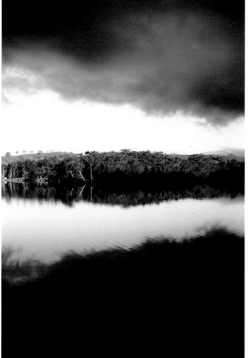

Reservoir,
Adelaide Hills, Australia

A bank of black clouds crossed the road just as we were driving past a small reservoir late one afternoon. The warm light and reflections in the reservoir provided a great opportunity.

◀ 35mm SLR, 28-135mm lens, f11, Ektachrome 100, tripod

REFLECTIONS

Reflections work well because they repeat shapes, and humans love to see repetition in images. When photographing naturally occurring reflections, there are two things to be aware of. The first is that the reflection is not as bright as the real thing – it's one to three stops darker. A graduated neutral density filter will reduce the light from above to match the reflection below. Second, reflections can get mixed up with what lies below the water's surface and sometimes this can be part of a reflection's appeal. However, if you don't want what's below to show through, a polarising filter can be a great help, as it will emphasise the reflection. (Similarly, the polarising filter can be turned the other way to remove the reflection altogether.)

When you find a great reflection, it can be tempting to ignore everything else. However, it's important to carefully consider your framing and composition. Try to exclude unnecessary elements so your viewers can concentrate on the reflection and not be distracted.

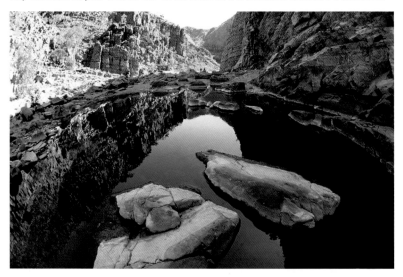

Ormiston Gorge, MacDonnell Ranges, Australia

You can see clearly how the reflected image is darker than the real thing. It was important to maintain detail in the red cliffs, making their reflections considerably darker. However, the blue sky and light rocks provide a point of contrast against the dark pool. A fish-eye lens creates the curved perspective.

▲ 35mm SLR, 16mm fish-eye lens, f16, Velvia, tripod

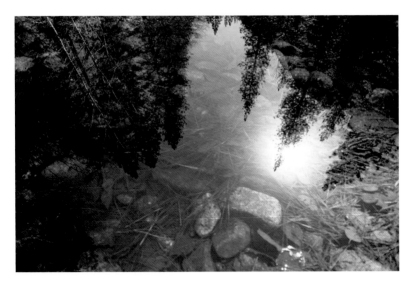

Pool reflection, Yosemite National Park, USA

This still pool and its surrounding trees made an interesting diversion from the usual grandeur and majesty of Yosemite National Park. While a polarising filter could have removed much of the debris on the pool's bottom, the combination of 'above' and 'below' worked a lot better. Note how the sun, still high, has been positioned behind a tree so it doesn't dominate the image.

▲ 35mm SLR, 28-135mm lens, f11, Kodachrome 64

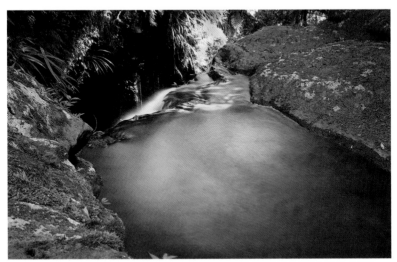

Elabana Falls, Lamington National Park, Australia

Reflections don't have to be perfect replicas of the surroundings. They can also reflect colour, as in this image. The running water won't reflect a clear image, but when the shutter speed is lengthened it reflects colour beautifully.

▲ DSLR, 35mm lens, f22, ISO 100, 4072 x 2708, RAW, tripod

TWILIGHT

Just before sunrise and just after sunset the light of the sky illuminates the land, and this is known as twilight. Sunlight bounces around particles suspended in our atmosphere and produces a beautifully soft and flattering light. Depending on the season and location, twilight can last for a few minutes (it goes very quickly in the tropics) or for an hour or more (it can last most of the day at the poles).

Twilight is characterised by a cool, silvery light from the sky, sometimes joined by a warm, golden light which is the beginning of sunrise or the remnants of sunset. The contrast of warm and cool light can be beautiful. Reciprocity failure, when colour film and digital sensors produce colour shifts during long exposures, can add to the effect with a palette of soft, pastel hues.

There is very little light at twilight, so long shutter speeds of several seconds and even minutes are required. You'll also need a tripod and a cable release.

Green's Pool, Denmark, Australia

The sun had set around 30 minutes earlier, but it was hard to drag myself away from the silhouetted rocks. A long 30-second exposure blurred the water in the foreground and the twilight produced a silvery blue light.

▶ DSLR, 85mm lens, 30 secs f6.3, ISO 100, 4072 x 2708, RAW, tripod

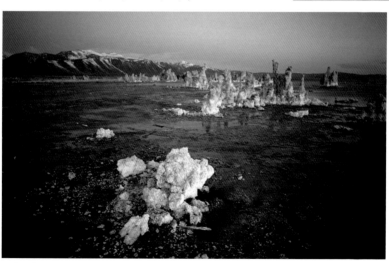

Tufas, Mono Lake, USA

Mono Lake is a popular destination for many photographers. As the lake level dropped, tufa were revealed to create an eerie, unworldly landscape. This early-morning shot required a tripod, cable release and warm gloves.

▲ 35mm SLR, 20mm lens, f16, Kodachrome 64, tripod

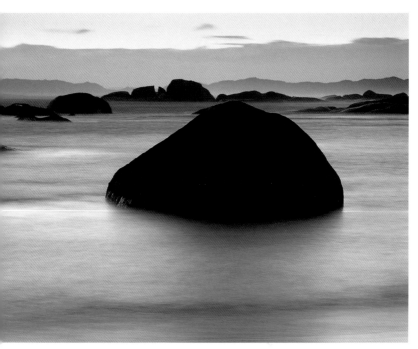

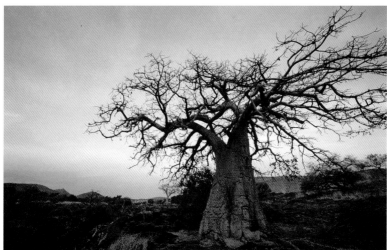

Baobab tree, Epupa Falls, Namibia

I waited for the sun to set so we could shoot into the chasm at the falls, but at the same time I received a twilight spectacle.

▲ 35mm SLR, 20mm lens, f5.6, Velvia, tripod

NIGHT

While our eyes struggle at night to see detail, if you leave a camera shutter open long enough, film or digital sensors will capture it all. Many photographers use exposures of several hours to photograph the landscape by the light of the stars, or of up to an hour for moonlit vistas.

As at twilight, film and digital sensors suffer from reciprocity failure at night. There are two consequences with really long exposures: a colour shift (which generally improves the image) and a loss of sensitivity.

Without getting too technical, if your light meter recommends an exposure of 30 seconds, give it one minute. If you have an exposure you think should be four minutes, you might need to give it eight minutes or even 16 minutes. When shooting at night, overexposure by one or two stops is usually a good idea, and if in doubt, bracket. This will give you night photographs with lots of detail.

It is possible to shoot landscapes by starlight alone, but it will require an exposure of several hours (depending on the film speed, the aperture and the location). Moonlight is stronger and similar images can be captured with much shorter exposures.

Sometimes it's possible to include other light sources within the photograph, such as the moon, car lights or even a candle inside a tent. These light sources can become

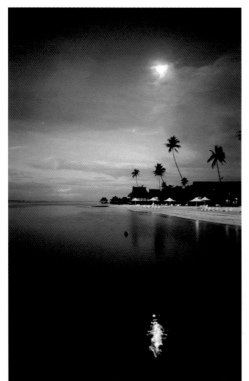

centres of interest, but don't rely on them to illuminate the rest of the landscape – they can't. You'll still need a long exposure for this.

A small torch is useful to help you set up the camera and a tripod is essential!

Pacific moon, Tahiti

The best thing about night photography in the tropics is it's warm! If you include the moon in the photograph, don't expect a sharp, clearly defined sphere, because during a one-minute or one-hour exposure, its movement will cause a blur. (Night photos where the moon appears really sharp probably use a double exposure.)

◀ 35mm SLR, 24mm lens, f2.8, Ektachrome 100, tripod

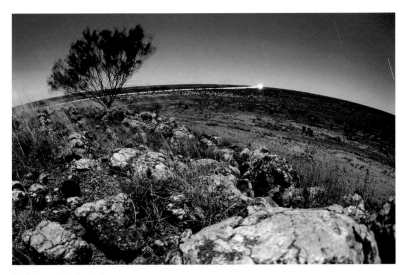

Truck headlights, Australia

We were camped overnight just behind a small hillock, so after dinner I grabbed my tripod and walked up to the top. There was a full moon, which provided the overall illumination, and just toward the end of the 30-minute exposure a truck drove along a road in the distance (I had forgotten it was even there). Despite being distinctly unhappy at the time, I found the result very pleasing!

▲ 35mm SLR, 16mm fish-eye lens, 30 mins f2.8, Velvia, tripod

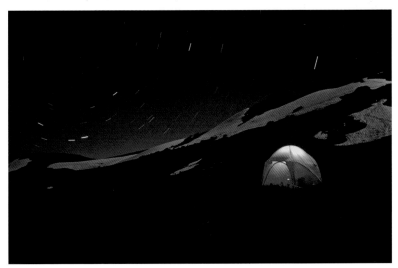

Snowy Mountains campsite, Australia

Australia's Snowy Mountains are really just well-rounded hills. This image included our tent, which had a single candle burning inside.

▲ 35mm SLR, 16mm fish-eye lens, 15 mins f2.8, Kodachrome, tripod

SILHOUETTES

Silhouettes make really powerful photographs as long as you get the shape, position and blackness of the silhouetted subject correct. Silhouettes in the landscape are easiest to create around sunrise and sunset because you can contrast the inky blackness of the silhouette with a colourful sky or clouds.

Fortunately, creating silhouettes is easy as long as you are looking into the light and your subject is between you and the light. This is a classic 'back light' situation, with no fill-in light providing detail of the subject. Most camera meters will be greatly affected by the sky and your subject will be recorded as black. However, if in doubt, also underexpose by one or two stops.

When photographing silhouettes, pay particular attention to how they fill the frame. Many silhouette photos fail because the silhouette is relatively insignificant within the frame. If you make your silhouetted subject dominant, your photos will have much more impact.

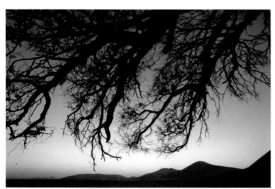

**Near Dune 45,
Namib Desert, Namibia**

As the sun set, the distant dunes put on a great light show. A foreground of sand seemed boring, and so did a plain blue sky (we hardly saw a cloud for 28 days), so I sprinted over the sand to some large trees nearby. I attached a 14mm ultra wide-angle lens and looked up. The silhouetted tree branches made a great contrast to the dunes below.

◄ 35mm SLR, 14mm lens, f5.6, Ektachrome 100, tripod

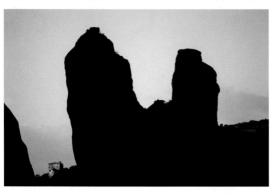

**Rousanou Monastery,
Meteora, Greece**

These amazing stone monoliths rise out of the plain and haze like giant marbles. Once you get in between them (there is a network of roads and villages), some amazing shapes and forms appear towering above you. Here the huge fork of rock is balanced by the tiny monastery which is lit by the setting sun. The image was underexposed by a stop to ensure the silhouettes were black.

◄ 35mm SLR, 28-135mm lens, f8, Velvia, tripod

Coconut trees, Fiji

Late one afternoon, while walking along the beach and watching the sunset, I turned around to see this pattern of coconut trees silhouetted against a pastel sky. What attracted me to the image was the repetition of shapes, but in different sizes.

▶ 35mm SLR, 20mm lens, f2.8, Velvia

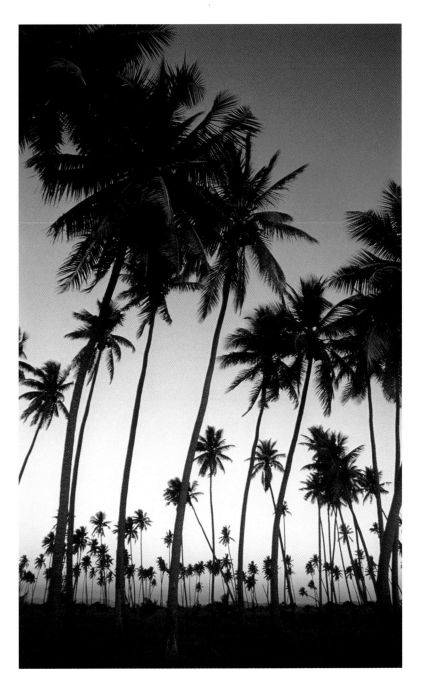

AERIALS

One of the best ways to really get to know a location is to hire a plane or a helicopter and fly over it. While it's an expensive exercise, you'll get some great photographs if you can ensure a window seat. The middle of the day can be fine, depending on what you're photographing on the ground, the shape of the land and what you're looking for. Some pattern shots can look great at midday. Even so, early morning and late afternoon are still best, as there are great shadows.

When shooting from the air:

▸ Use a standard zoom lens (eg 35-70mm); a wide-angle lens will catch the wings or the helicopter blades, while a long telephoto will exaggerate the inevitable camera shake associated with the aircraft.
▸ Ask the pilot to remove the door (ensure your seatbelt is secure!)
▸ Use fast shutter speeds – at least 1/125, and faster if in a helicopter.
▸ Try to keep your camera just inside the aircraft to reduce buffeting.
▸ Don't lean your camera against the aircraft door – the vibration will ruin your photos.

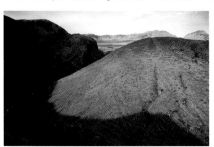

Ormiston Gorge, Australia

A late-afternoon helicopter flight was not good for photographing inside the gorge, but the deep shadows created an interesting shape that worked well with the tops of the hills and the distant ranges.

◀ 35mm SLR, 28-135mm lens, f4.5, Velvia

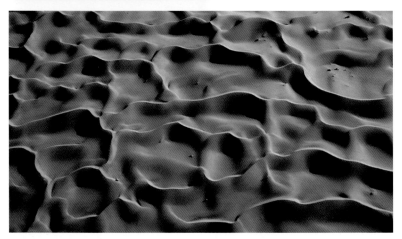

Sand dunes, Namib Desert, Namibia

I am guessing we were at about 600m (2000ft) when I took this photo. I had been looking out toward the horizon when something prompted me to look down. This shot is successful because the pattern fills the frame and there are no points of reference to give it scale.

▲ 35mm SLR, 28-135mm lens, f8, Velvia

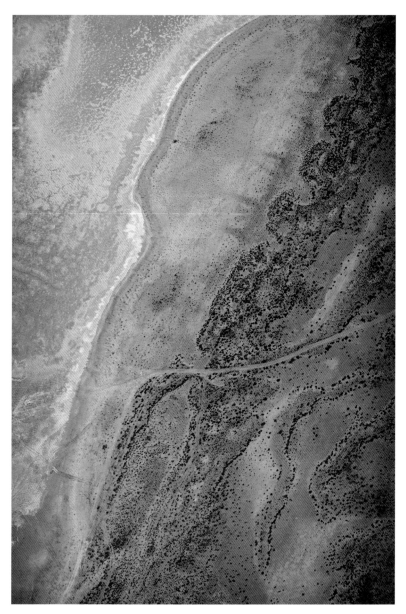

Desert patterns, Kalgoorlie, Australia

A mid-morning flight meant the sun was nearly overhead, but for this pattern photo it was ideal, flattening out any relief and producing a painterly rendition. You don't need a zoom lens; just ask your pilot to fly higher or lower.

▲ DSLR, 50mm lens, f5.6, ISO 100, 4072 x 2708, RAW

FAMOUS PLACES

If you're creating a travel record of your journey, then photos of famous places are every bit as important as shots of unusual or little known places. Icon photos give your viewers a reference point that can give your other photos more relevance and context.

However, there's nothing wrong with trying to take something a little different. After you've exposed the stock-standard postcard photo, keep shooting. You never know what you might come up with.

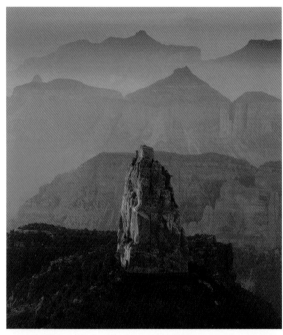

Mt Hayden at sunset from Point Imperial, Grand Canyon National Park, USA

Famous places have been photographed by everyone so to create a unique image is always a challenge. In this case the difference was created when the warm light at sunrise was enhanced by smoke from forest fires.

◀ 6 x 4.5cm SLR, 75mm lens, 1/4 sec, Velvia 50, 81C filter, tripod

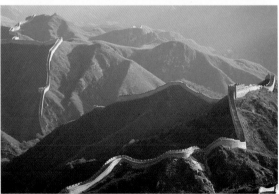

Great Wall, Bandaling, China

Although sunny, it was far from warm and pleasant. At -10°C and with a 40-knot wind buffeting me around, shooting was decidedly uncomfortable. Fortunately, the subject matter was engrossing and I hardly gave the conditions a second thought.

◀ 35mm SLR, 28-135mm lens, f8, Velvia

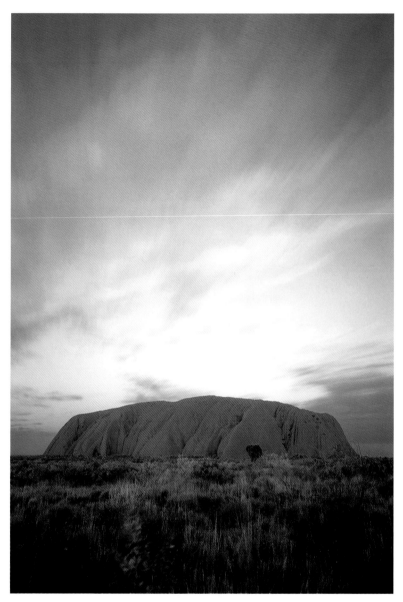

Uluru, Uluru-Kata Tjuta National Park, Australia

'Sunset strip' is always full of buses, cars and tripods at sunset. It's hard to take a photo that's unique, so I decided to make it excellent quality. I used a 4 x 5in large-format camera and I was more than happy with the result. This image has been cropped vertically for reproduction.

▲ 4 x 5in large-format camera, 90mm lens, f32, Velvia, tripod

HUMAN SCALE

While most of the photographs in this book are without signs of people, the use of a human figure, a road or a building can give a landscape a sense of scale. Without a reference, many subjects might be huge in scale or quite intimate and small – the viewer won't know.

Sometimes photographers like to hide the scale of a location, causing the viewer to ask questions and become involved in the image. On other occasions, positioning a person, an animal or a small house within a scene can make the scale one of the most important compositional elements.

If you're travelling to popular tourist destinations, it might not be possible to photograph them without people or signs of human habitation. One option is to edit the image digitally, removing unwanted elements; a second option is to make the signs of man a feature of the photograph.

Note, if you intend to make commercial use (submit to an image library, or otherwise license or sell) of photographs of clearly recognisable people (or private property, artworks or trademarks), you should consider obtaining a release. Model and property releases grant permission from a person or rights holder to use their image or property in a photograph.

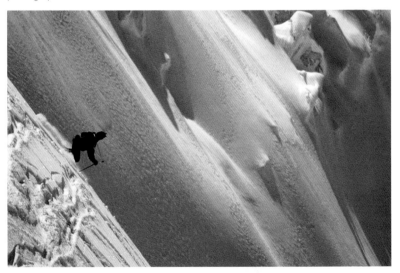

Skier, Carriboo Mountains, Canada

The immense size of the glacier in the background only becomes apparent when compared to the size of the skier, a known dimension we can all relate to.

▲ 35mm SLR, 28-135mm lens, f6.6, Ektachrome

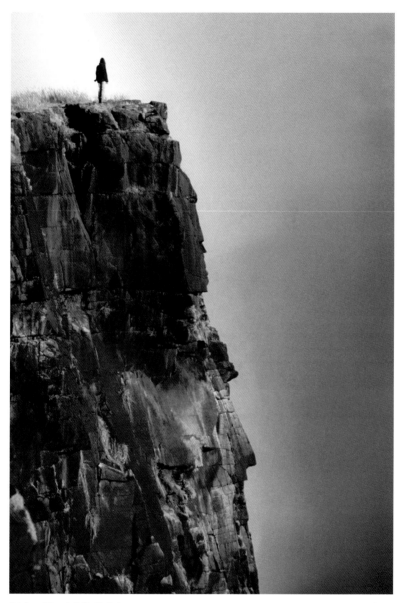

Rainbow, Victoria Falls, Zimbabwe

After researching the local souvenir shop for camera angles, I worked out the time of day that the rock face would be lit up and asked my kind wife to pose, her figure adding scale to the size of both the rock and the rainbow behind it. The image was underexposed by half a stop to increase the colour saturation.

▲ 35mm SLR, 180mm lens, 1/250 f5.6, Ektachrome E100SW

BUILDINGS IN THE LANDSCAPE

Buildings and other structures in the landscape serve two purposes. First, like human figures and animals, they provide images with a sense of scale, although obviously buildings can be quite different in size, so that sense of scale is not as precise as with a human figure.

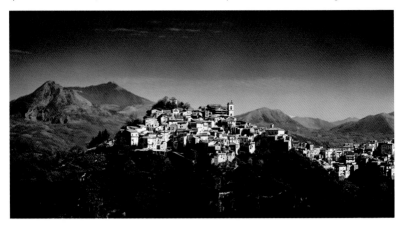

Rivello, Basilicata, Italy

Using a moderate telephoto lens, I waited several hours (over lunch) for the light to improve. The negative was then scanned and the final post-production done with image-editing software. The background has been blurred slightly.

▲ 6 x 9cm large-format camera, 150mm lens, f22, T-Max 100, tripod

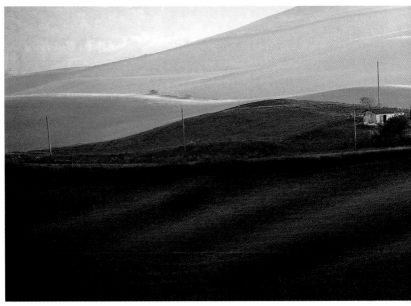

Perhaps more importantly, buildings can provide landscapes with a centre of interest. Without the building, the landscape could appear a little bland. Add in a building and the building and landscape work together to create a much more enjoyable photograph.

Buildings with special architectural styles can also tell the viewer a lot about the country or locality of the photograph. This can be useful in a travelogue.

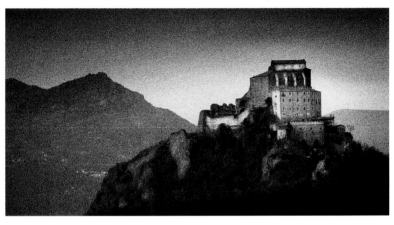

Abbey, northern Italy

When I walked up the stairs into this abbey, the beautiful sounds of a Gregorian choir were echoing through the corridors. At the top I found that the singing was emanating from a small CD player! However, this view placated my disappointment. All compositional lines in the image lead to the abbey, making it the image's dominant centre of interest. Late-evening light ensured there is detail throughout the image.

▲ 35mm SLR, 28-135mm lens, f16, APX100, tripod

Tuscan farmhouse, Italy

The sun was hovering close to the horizon and the light was magic as I drove through the Tuscan hills. All I needed was something to photograph. I turned the corner and this is what I saw. In a mad scramble (just in case the light changed) I set up the tripod and used a 100-400mm zoom to frame the image. Image-editing software was used to enhance the colour for the final print.

◀ DSLR, 100-400mm lens, f22, ISO 800, 4072 x 2708, RAW, tripod

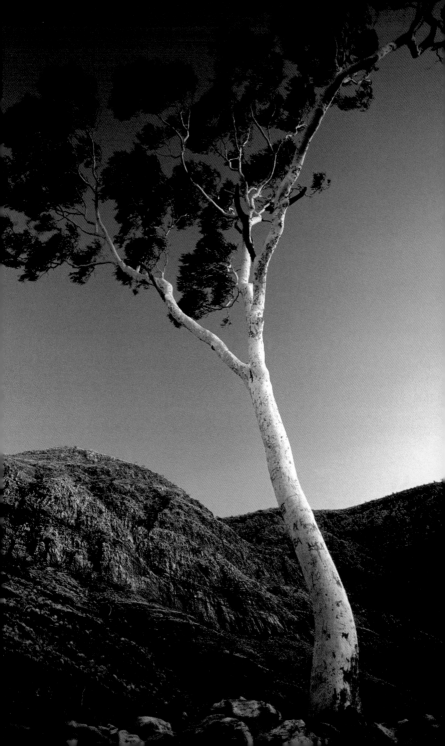

PART FOUR:

The worst thing a landscape photographer can do when back at home is to leave their best photographs in a folder or a box, unloved and unseen. At the very least you should plan ways of displaying your work to friends and family. And at best, you can take your favourite images and work on them further, either in a darkroom or on a computer using an image-editing program.

BACK AT HOME

Ghost gum, Ormiston Gorge, Australia
◀ 35mm SLR, 20mm lens, f8, Velvia, tripod

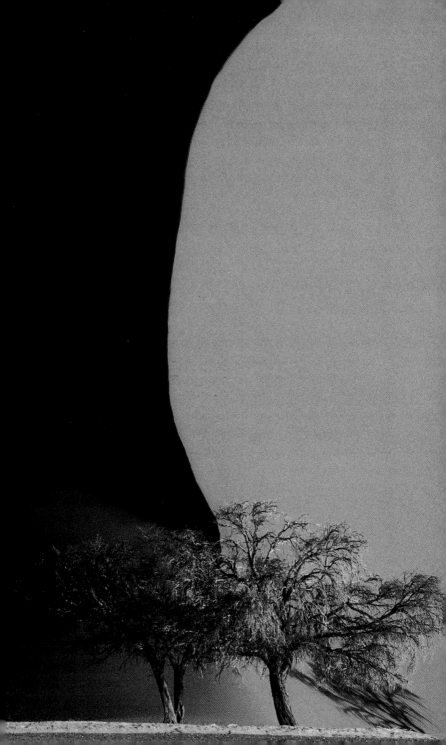

PRINTING FROM FILM

The photographer working in a darkroom generally hand-prints the photos. A film processing lab (or minilab) uses a machine to produce prints. In both situations, there are two steps involved in producing a print. First, the film is developed to produce a negative; second, the negative is used to produce a print.

In colour photography, there is basically one process used for developing all colour negative film types and another for developing all colour prints. While you can make adjustments for colour balance and exposure during printing, the processing itself is standardised.

You can also process and print colour transparency film (slides), but this is generally more expensive. However, scanning slides and then printing is a newer, cheaper option.

In black-and-white photography, there is a plethora of different film developers, print developers and printing papers. Quite different outcomes can be produced with different combinations, and many photographers have spent years refining their craft to create particular looks or effects in their prints. While exposing the printing paper under the enlarger (a device that projects the image of the negative onto light-sensitive photographic paper), the photographer can add and subtract light (exposure) to lighten and darken areas in the print so that attention is drawn to the areas they wish to emphasise. For instance, the sky can be changed from an insipid light grey to a rich, dark black, or a dark shadow can be lightened to include essential detail. Sometimes photographers will make several dozen small adjustments to the base exposure to produce the effect they are after. Experienced photographers with darkroom skills can transform average negatives into sensational prints.

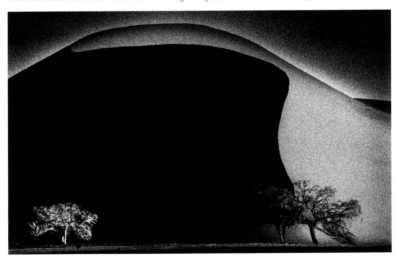

Dune 45, Sesrium, Namibia

Named Dune 45 because it is 45km from town, this is a popular tourist stop. Amazingly, the dunes only move a few inches each year. The strong shapes are ideal for working with in black and white, but the only way to get an image looking like this is to produce a custom print.

▲ 35mm SLR, 300mm lens, f8, T-Max 100, tripod

◀ 35mm SLR, 300mm lens, f8, Velvia, tripod

If you send your film to a lab, chances are it will be machine printed. In fact, your average local minilab doesn't process black-and-white prints, at least not true black-and-white prints from black-and-white films. They are sent to a larger commercial lab. (There are some special chromogenic black-and-white films that can be processed in colour chemistry and printed on colour paper to look black and white, but these materials can't match the rich blacks that a true black-and-white process produces, unless the chromogenic negative is printed onto true black-and-white paper.)

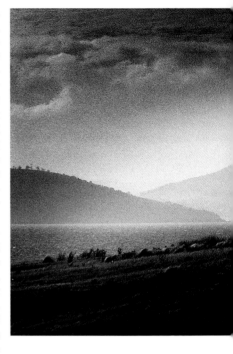

A commercial black-and-white laboratory will use standardised developing and printing processes, no matter what the type of black-and-white film. Similarly, when a print is made, it's a machine that makes a single exposure onto the paper. It cannot lighten or darken selected areas to improve the image and this is the greatest limitation with commercially produced black-and-white prints. There is no creative input after the original exposure.

If you're unhappy with commercially produced black-and-white prints, you can use a professional lab that provides custom printing. Custom printing simply means a darkroom worker will manually produce your print and, according to your instructions, lighten or darken areas of the print to produce a better result. This is better than a straight print, but not as good as being able to do it yourself.

Another option is to have your negative scanned to create a digital file and to then use an image-editing program on a computer to produce your prints. Instead of printing onto traditional photographic paper, you'll probably output them onto inkjet paper. A good black-and-white inkjet print can look a lot more impressive than an average black-and-white photo print.

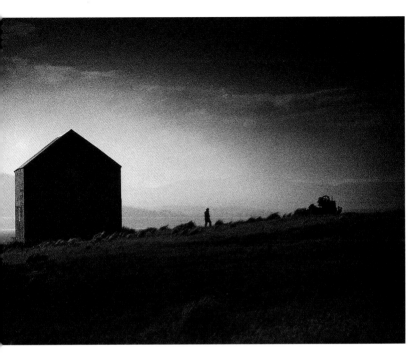

Old barn, Maria Island, Australia

The remains of an old penal settlement are being gradually eroded by wind. This image was captured in black and white and 'split-toned', meaning the shadows were left black, but the highlights were given a light sepia tinge.

▲ 35mm rangefinder, 135mm lens, f8, T-Max 100

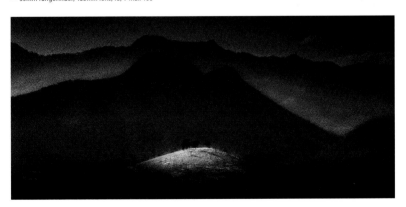

Small hill, Rathdowney, Australia

In the middle of the day, the light was overhead and harsh, but by visualising the end result, a few hours in the darkroom produced a completely different image with wonderful lighting. A similar effect could be produced with an image-manipulation program.

▲ 35mm SLR, 100-300mm lens, f16, APX 100, tripod

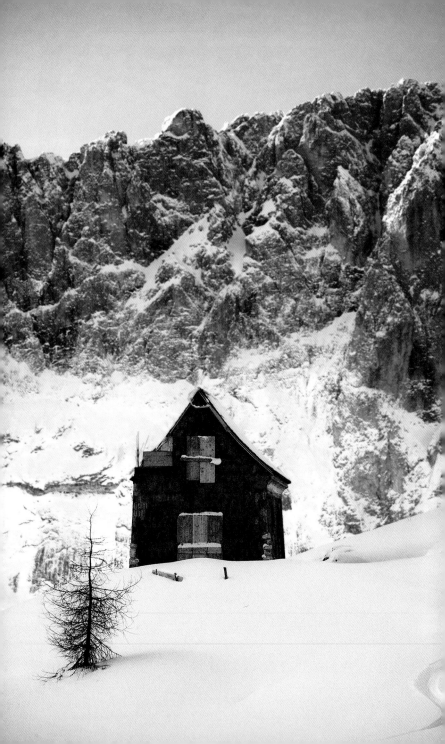

DIGITAL POST-PRODUCTION

Digital techniques encompass a huge range of options, from simple image improvements at one end (brightness, contrast, colour balance) to outlandish and imaginative constructions that bear no resemblance to reality.

Some photographers think it's cheating when you use digital techniques to change or enhance an image beyond what is possible with film techniques, but this is not a logical argument. Black-and-white photography bears no resemblance to reality, and different colour films can record landscape colours in a variety of ways. No film-based photograph truly represents reality, so why should we limit what we do with digital photography?

Originally, photographers needed a combination of skill, knowledge and time to create wonderful vistas and striking landscapes. Theirs was an art of observation more than creation. Today, if photographers have software skills and a vivid imagination, they can transform their observations into visualisations. What freedom!

On the following eight pages you will find eight digital post-production steps we recommend you apply to all your best landscape photographs.

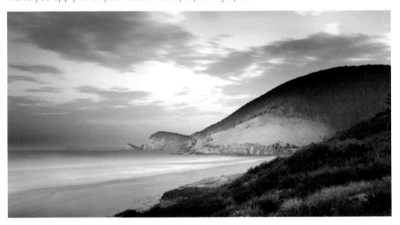

Blueys Beach, Australia

This is a combination of two exposures, one taken in the middle of the day (to produce the greens and blues of the water), and another at sunset (to capture the sky). Some severe lightening and darkening of various areas has followed in post-production.

▲ DSLR, 17-35mm lens, f22, ISO 100, 4072 x 2708, RAW

Alpine barn, Passo Gardena, Italy
◀ DSLR, 28-300mm lens, f6.3, ISO 800, 4072 x 2708, RAW

01 RETOUCHING

Unsightly spots and blemishes from dust and hairs sitting on top of the film or the digital sensor at the time of capture (or when scanning a negative or print) are the bane of photographers.

Dust and hair marks often don't show up until you make an enlargement, but it is good practice to remove these marks as a matter of habit. 'Spotting', to cover up these imperfections, is standard procedure in professional film studios. Spotting your digital files is relatively simple. Working at 100%, make a copy of a small area next to the imperfection and paste it over the top of it. Most programs have a 'cloning' tool which makes this process easy. Sometimes it's a good idea to soften the edges of the cloning tool or the spot you have covered up will have a new problem – a sharp edge around the area you have just spotted.

If you're using Adobe® Photoshop®, the best tool for the job is the Healing tool. There is also a filter called Dust and Scratches, but use this sparingly as it softens (blurs) the entire photograph to remove the dust and usually this isn't a good idea for landscapes.

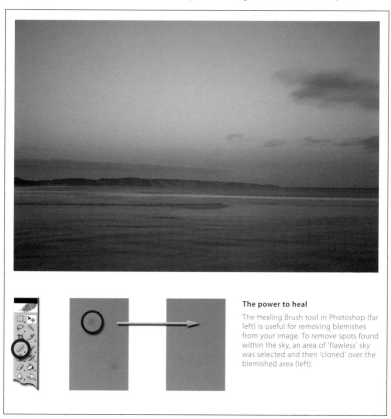

The power to heal

The Healing Brush tool in Photoshop (far left) is useful for removing blemishes from your image. To remove spots found within the sky, an area of 'flawless' sky was selected and then 'cloned' over the blemished area (left).

02 EXPOSURE & CONTRAST

Most cameras produce the correct exposure most of the time, but as discussed earlier in this book, correct exposure is often a matter of opinion. The beauty of digital photography (and of scanning your film images and working on them digitally) is that you have complete control over the exposure.

At this stage, we are looking for a correct, overall exposure. While it's possible to lighten parts of the image and darken others, it's good practice to obtain an exposure that is right for the most important parts of the image and worry about the other areas later.

There are many ways you can adjust the exposure of your digital photos. Most image-editing programs refer to exposure in terms of brightness and contrast. In fact, the most basic tool is the Brightness/Contrast control (which is found in all image-editing programs). This is a simple slider dialogue – open it up and slide the controls left or right; when you like what you see on the screen, press OK.

The Brightness/Contrast control is considered a bit basic by professional photographers and most will use the Levels and Curves controls (see next section).

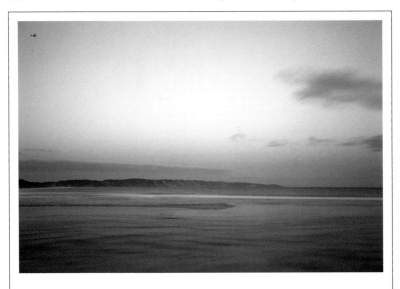

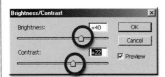

Brightness/Contrast

In Photoshop you can adjust the exposure of your image by using the Brightness/Contrast tool. Open the dialogue box (under the Image/Adjustments menu) and drag the sliders to the right to increase the image's brightness or contrast, or left to decrease the brightness and contrast. If you wish, you can also enter a numeric value.

03 ADVANCED EXPOSURE

Advanced and professional image editors use the Levels and Curves controls to adjust the brightness and contrast in an image.

The Levels control will be familiar, as it uses the same histogram that you see on your camera. The histogram graphs the exposure values in the image, with blacks on the left and whites on the right. If the values on the graph don't extend to the edges, this indicates that your photo doesn't have blacks or whites in it. On the other hand, if the values are all up one end, it indicates you have too many blacks or too many whites. Using the three slider controls under the graph, you can adjust the exposure and the contrast.

The Curves control can be used to do much the same job as the histogram, except you don't have a graph showing you where your values lie. Instead, you start with a straight diagonal line. By placing points on this line and dragging them upwards or downwards, you can create a 'curve'. Small adjustments to this line can produce dramatic changes to your exposure and contrast.

The results achievable with Levels and Curves give you more control than the simple Brightness/Contrast control. You can also use Auto Levels, Auto Contrast or Auto Color in Photoshop for a very good result automatically.

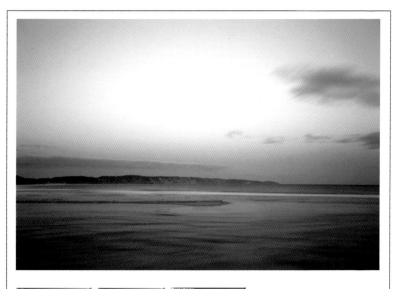

Advanced exposure

The powerful Levels (far left) and Curves (middle) functions of Photoshop allow you to have more control when adjusting the exposure of your images. The Auto Level, Auto Contrast and Auto Color tools (left) provide instant adjustments.

04 COLOUR

Digital post-production is wonderful for colour. You can make subtle or dramatic changes and, if you don't like the result, you can undo what you've done and try again. Most programs have a colour-balance control that allows you to increase or decrease the red, green or blue channels. Normally you don't need to make much of an adjustment to get the result you're after because most adjustments simply remove a slight colour cast or warm up the light.

The colour balance control is great if you know the colour adjustment required, but sometimes when you look at your photos, working out the problem isn't so easy. Some image-editing programs create a series of variations showing what happens if you add red, blue or green (and/or magenta, cyan and yellow).

When making colour adjustments, it is obviously extremely important that your computer monitor is correctly calibrated and is displaying accurate colours. If your computer monitor has a colour cast itself, you will be chasing your tail trying to produce the right colour in your prints.

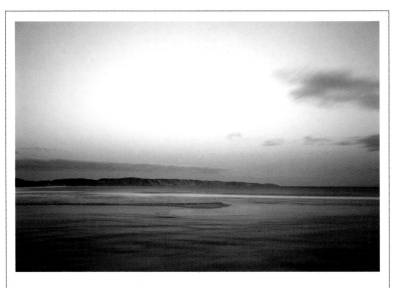

Colour control

The Variations tool in Photoshop allows the user to add or remove colour from an image as well as adjust the image colour saturation. Previews are generated showing the results of colour and/or colour saturation being added or removed.

05 CROPPING

Many images can be improved by cropping. Sometimes cropping can be used to remove unwanted elements in the photograph, while in other situations a different format may look better.

All image-editing programs have a cropping tool. Most allow you to trace the shape of the crop you want and to darken the areas to be discarded, giving you a clear idea of what is happening to the image.

When cropping your images, don't be scared to try different formats. Long, thin panoramas, vertical slices and square images can all work really well with the right subject matter. And keep in mind how you're going to use the final image and if it will be framed.

If you're worried about your cropping, save a copy of the original file so you can return to it should the need arise.

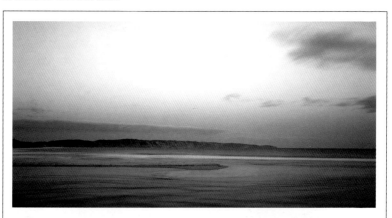

 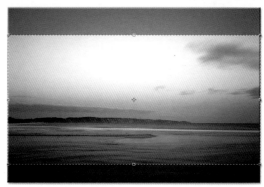

Keep the best, crop the rest

The Cropping tool in Photoshop was used to create a panorama of the beach. Simply drag the cropping window to select the area of image you wish to keep and your image will be reduced to the new size.

06 FINE-TUNING

The fine-tuning of a digital print allows for many options. You may choose to move or remove elements within the scene to make a photograph that better reflects your impression of the landscape, even if it doesn't accurately represent reality. You can even add in elements; the most common addition in a landscape is a new sky. Very often you'll visit a great location, but the weather isn't optimum. Adding a sky is not necessarily a quick job, but the results can be breathtaking and transform your landscape from the mundane to the sublime.

Colour is another aspect you might like to consider. Once you've produced a correct colour balance there's nothing to stop you from enhancing or even changing colours. For instance, you could increase the greens in a field of grass or the blues in the sky. You can also reduce the colour saturation in the image, or reduce it in some parts and increase it in others.

Most image-editing programs also offer a whole host of filters or special effects you can play with. Sometimes these effects are a quick and easy way to produce an image with a difference, but they shouldn't be overused. If you apply special effects to all of your images, you'll end up with a bunch of chocolate-box clichés. Fine tune, but don't drown your photos with digital effects.

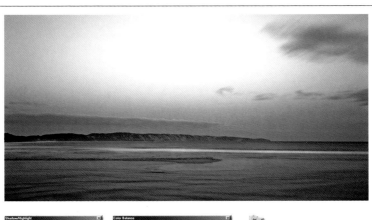

Fine-tuning your image

For the example shown here, three simple processes were applied in Photoshop. First, the Shadow/Highlight dialogue was used to create more separation in the background, lightening the foreground and the distant cliffs to make them more prominent. Second, the Color Balance dialogue was used to create a much warmer colour balance, increasing the red and yellow content of highlights, mid-tones and shadows. Finally, the Dodging (lightening) tool was applied to highlights to gently lighten the breaking waves on the beach. Obviously many more things could be done to improve or enhance this image, but one of the skills digital photographers also need to learn is knowing when to stop!

07 VIGNETTING

As a finishing touch you might consider vignetting the image. Vignetting is the process of darkening the edges of the photo so the centre is the lightest part. Photographs where the edges are lighter than the centre can appear unfinished, mainly because our eyes tend to concentrate on lighter areas. If you want your viewers to keep looking around your image, contain their roving eyes by darkening the edges.

There are several ways you can darken the edges, but however you do it the effect should be reasonably subtle. Your viewers shouldn't be able to see the transition area.

One technique for vignetting the edges of your print is to use the Lasso tool. First draw a rough circle around the edges of the image. This selects the middle of the photo, so invert the lasso to select the outside edges of the image. Set the feathering to the highest value possible to create a gradual transition with no hard edges. Choose the Curves dialogue and drag the curve down slightly. This darkens the edges. Deselect and repeat several times. It is better to vignette in small, varied steps than to make one big change.

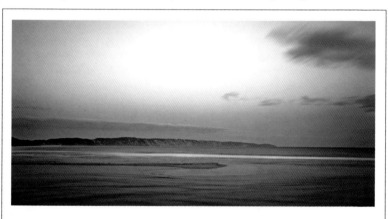

 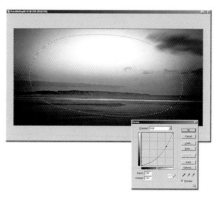

Vignetting

Using the Lasso tool in Photoshop (far left), select an area of your image that will contain the vignette (left). Invert the selection (Inverse, under the Select menu) and use the Curves dialogue box (under the Image/Adjustments menu) to create the desired vignette effect.

08 SHARPENING

Sharpening is the process of making your photographs look clear and full of detail. Funnily enough, all sharpening involves a process called 'unsharp masking'. Most digital cameras apply some sharpening to your photos at the time of exposure, but generally this is just low-level sharpening.

Most photographers will apply additional sharpening to the images as the last step before making a print or posting an image onto the Internet. This is especially important for landscape photographs when you want the appearance of lots of detail and high resolution.

Before sharpening an image, make a copy of the unsharpened file and store it away. Then size the image to the required output size – perhaps the size of the paper you are printing on. Now the program knows how big your print will be.

Most image-editing programs have a Sharpen control and a Sharpen More control. Enlarge the image on your screen to 100% and press the Sharpen control once. If the image looks better, save your file. If not, press Sharpen again, or even press the Sharpen More control. If you have applied too much sharpening, your image will start to look spotty or show white lines around the edges of your subjects.

A sharper image

An image can be sharpened quicky using the Sharpening tools in Photoshop (far left), located under the Filter/Sharpen menu. For more control over the image sharpening process, use the Unsharp Mask option in this menu (left).

To see the effects of sharpening, compare this photo with the previous one. We have oversharpened this file just a tad so you can clearly see what's happening.

PRINTING DIGITAL FILES

Unless your viewers are happy looking at your images on a computer screen, you'll want to make a print. Many readers will have an inkjet printer which can produce remarkably high quality prints. If your printer is reasonably new and working properly, your prints should look pretty much like the image you see on your computer screen.

You can also save a copy of your image onto a CD or storage card and take it to a photo lab. A photo lab can produce a photographic quality print on photographic paper. Again, the colour and contrast in the print should match what you saw on your computer screen. If it doesn't, ask the lab for some advice on setting up your computer to match its printer.

Other options are the new photo booths and kiosks that are popping up in shopping centres and airports. Although many of these are designed to print photos straight from a digital camera, there's nothing to stop you copying your finished photos onto a storage card and using the booth.

Whatever you do, make sure you make a print, as technology may not be able to read your digital file in 20 years' time.

COLOUR TO BLACK & WHITE

When a digital camera captures an image, light passes through an array of tiny filters over the sensor. The filters are red, green or blue and if you look at one of your photos in a program like Photoshop, you'll see your colour photograph is actually made up of three black-and-white images (called channels). Each channel shows the same subject, but with different tonal values depending on how much red, blue or green is in the subject.

When you turn a colour (RGB) image into a black-and-white one, the computer throws away most colour information. Generally it keeps a predetermined proportion of red, green and blue information from which it produces the black and white. You can create the black and white by turning your RGB file into a greyscale file, or you can use a desaturation control to create the same effect, except you still have an RGB file. The only problem with both

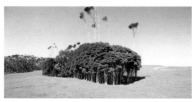

Original colour image

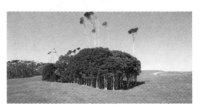

Greyscale – notice the light blue sky and dark foliage.

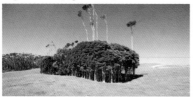

Red channel – notice the improved sky and foliage.

Tree stand, west coast of Tasmania, Australia

When working digitally, you can sometimes get a better black-and-white image from a colour file by using the red channel, instead of converting directly to greyscale.

◀ DSLR, 16-35mm lens, f6.3

these approaches is that you're stuck with set proportions of red, blue and green information that might not be the best proportions for a particular photograph.

Instead of using the program's pre-set conversion process, there are ways you can determine how particular colours are changed to tones of grey. You can use the Channel Mixer control in Photoshop, special plug-in filters which make the process easier than the Channel Mixer (such as the Imaging Factory's Convert to B&W Pro). And for landscape photography, you can simply use the red channel. Just as a red filter can make black-and-white film photos look strong and dramatic, so the red channel in a digital file can produce a similar result. Specifically, the red channel can produce darker blue skies, just like a red filter.

To use the red channel, all you need to do is open your photo in a program like Photoshop and select the Channels control. You will see four layers: RGB, red, green and blue. Make a copy of the red channel (drag the red channel down to the New Channel icon). Now select and delete the remaining channels. Finally, go to Image/Mode, where you will find you now have a multichannel file; change it to greyscale. Now you have a quality black-and-white image ready for printing.

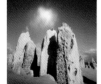

Step 1

Step 2

Step 3

Step 4

Step 5

Pinnacles, Australia

Using a 16mm lens and a low camera position, these three lumps of rocks were isolated against a deep blue sky. I waited for a few minutes for the cloud to roll into position.

◀ DSLR, 16-35mm lens, f22, ND filter, tripod

Here is how it was processed digitally:

Step 1

This is the base photograph after converting it from a colour digital file. The top of the sky is nice and dark, but the rocks themselves are similar in tone to the foreground sand.

Step 2

Using the Curves control in Photoshop, the overall contrast of the image is increased and the exposure darkened fractionally. This is similar to using a higher-contrast paper or filter in traditional darkroom black-and-white printing.

Step 3

Using the Dodging tool in Photoshop, set with a very soft brush for highlights, the cloud is lightened. This increases the contrast between the cloud and the surrounding sky, making it more dominant in the composition.

Step 4

The foreground and the sky are darkened so the lightest parts of the image are the three rocks and the cloud. This is done using the Burning tool (next to the Dodging tool), again with a soft brush, set to mid-tones.

Step 5

The final step is to turn the greyscale image into an RGB file so it can be coloured. Using the Hue/Saturation control, the Colorize checkbox is ticked and the Hue and Saturation sliders adjusted to produce the sepia tone.

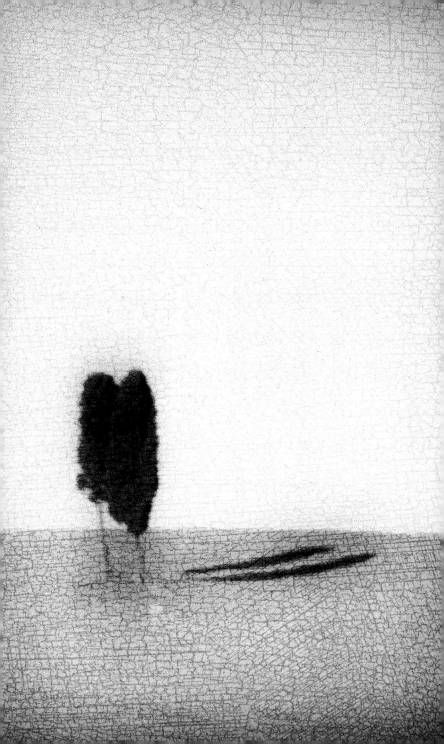

SHOWING OFF

When your prints come back from the lab, or you pull one out of the inkjet printer tray, what do you do next? Many photographs are carefully placed in top drawers or shoeboxes, never to see the light of day again. What a pity!

Half the fun of being a photographer is showing your work to family, friends or even the world. There really is nothing better than someone viewing your work and paying you a compliment. And landscape shots taken while you're travelling will be of great interest purely because of the subject matter.

The presentation of the image is almost as important as the image itself. A small, dog-eared print may be quickly passed over, but the same image with a large white border and frame will be admired. Take a few lessons from professional photographers – they don't just throw a few prints across the table and hope you like them. Their prints are presented in folders or albums which subliminally suggest that the photos are so good and valuable they need taking care of.

When you create a great landscape photograph, make sure you present it properly. Make a statement that shows how important the photograph is to you.

Twin trees, Tuscany, Italy
◀ 5mm SLR, 100-300mm lens, f11, APX 100, tripod

FRAMING

A frame is a great way to present your best photographs. Generally speaking, you'll need to make an enlargement, although there's no reason a small print can't look great on the wall, especially with a large matt (the board that surrounds the print within the frame).

There are a number of issues to consider: the size of the photograph, the size of the frame, the colour of the matt, the material and colour of the frame, and the amount of space between the photo and the frame.

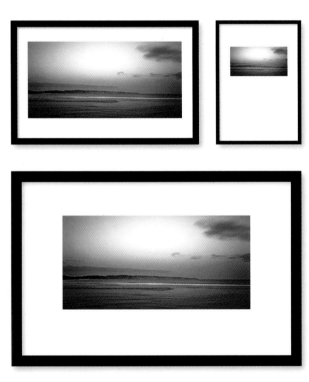

Framing options

A great way to work out what you like is to create some frames in your image-editing software. Make a rectangle, add some inner and outer shadows and thicken up the stroke (the line around the rectangle). Now drop your photo into the frame and adjust all the elements: frame thickness and size, photo size, matt colour and image cropping.

Size

Big isn't always better, but there's no doubt a large high-quality print can have great impact. To determine how large you can print your landscape photographs, it's best to start with your camera. Most 35mm film cameras are capable of producing prints of up to 75cm (30in) across. Medium- and large-format cameras will allow prints up to several metres in size. The size of prints possible from a digital camera depends on both the sensor size and your computer skills, as it is possible to increase the size of digital files without noticeably losing quality (Photoshop plug-ins such as Genuine Fractals work very well).

When considering the size of your print, remember the surrounding matt may increase the size of the finished work. You should also consider whether the image would look better cropped to a different format. For instance, many of the 'panorama' photographs reproduced in this book were taken with a 35mm SLR camera and cropped to size. Just because you order a 20cm x 25cm enlargement, doesn't mean you can't crop it before framing.

Frames

Photographs can be mounted with or without frames. Like clothing and hairstyles, frame styles go in and out of fashion.

In most public galleries, photographs are framed with a reasonably wide white matt, creating a border between the edge of the print and the frame. The frame itself is usually black or possibly a dark brown. The trend seems to be for simple frames that allow viewers to concentrate on the photograph within. More elaborate frames can certainly add to the experience of your photography, but care should be exercised. Very often less is more and we certainly recommend simplicity.

Frames can also be thick or thin, wide or narrow. Again, fashion often dictates what you can buy, but smaller prints generally look better with thinner frames. You don't want the frame to dominate the photograph. When considering your frame size and thickness, also consider where you're going to hang the finished work. Really small frames look a bit silly sitting alone on a large wall, while a large frame squashed into too small a space looks similarly awkward.

Matts

A matt gives the eye an area to rest in by separating the photograph from the surroundings in which it is viewed.

There is a temptation to select a matching colour when matting prints. If a photograph has a predominance of, say, greens, a green matt might seem like a good idea. However, strongly coloured matts are usually too dominant. The purpose of the matt is to emphasise the photograph, not to compete with it, so generally speaking neutral colours are better. The majority of prints will work best with a white or cream matt. Since people generally prefer warm colours, a slightly warm white is better than a cool or blue white.

Matts also come in a variety of textures, as sometimes a subtle texture is more attractive than a textureless surface. The most expensive matts are archival quality. Poor-quality matts can react with the photograph, especially when sealed within a frame, resulting in discolouration of both the matt and the photograph. If you value your images, use archival-quality materials.

ALBUMS

While frames are excellent for displaying your favourite images, most photographers have many more great shots that need to be displayed. An album or portfolio is the traditional way of displaying a body of photographs and even though most of the world is going digital, there's still nothing quite like turning the pages of a book full of beautiful images.

The first consideration when buying an album is to ensure that it is made from quality materials. If you want your landscape prints to last for many years to come, archival materials will resist yellowing and shouldn't adversely affect the print. The longevity of your album depends on where you keep it and where you live. Heat and humidity are not good for photography albums.

The most common album types have slip-in sleeves, allowing you to insert two, three or more photos per page, perhaps leaving room to write a few notes and dates alongside. These albums, assuming they are made with archival materials, are great for storing and quickly viewing a large number of prints that are all the same size. However, they are not particularly creative in their presentation.

Albums with plain pages requiring photo corners or adhesive to place your prints in position are a little more time-consuming to put together, but you have complete freedom when it comes to designing each page. You can place a single image or several, and they can be large in size or small. And if your landscapes are part of a trip, you can include other mementos such as tickets, wine labels and postcards.

The album cover can be an important feature and there are manufacturers around the world who specialise in designs for professional photographers. If you can afford the asking price, this is one way to give your presentation a smart and unusual twist.

Designing your album

One way to create a great album of landscapes is to use an image-editing program to design and lay out your pages. Print the results on a watercolour paper and have them professionally bound and your album will last a lifetime.

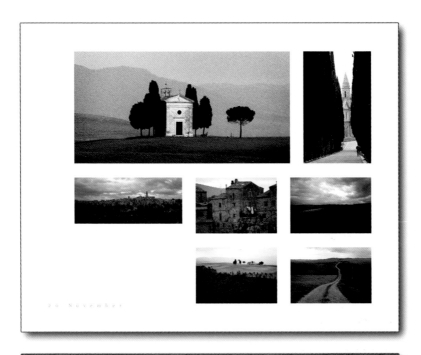

20 November

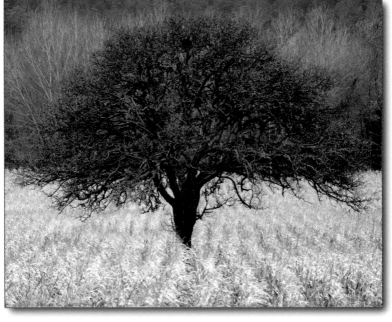

WEBSITES & EMAIL

There are millions and millions of photographs on the Internet, so why not add yours? If you don't want to show your landscape images to the world just yet, how about emailing your best ones to a few friends?

Since you're presenting your images on a computer screen, you don't need big files. In fact, for the Internet and email you generally want the smallest file size possible. Most computer screens are 800 x 600 or 1024 x 768 pixels in size, and digital files don't need to be any larger than this. Photos are best saved as a JPEG file type as they can be made very small and hence are very quick to transmit.

There are a number of issues to deal with when saving JPEGs for the Internet. Some programs (such as ImageReady®, which comes with Photoshop) are designed specifically to assist you. However, your existing image-editing program can be used and it's an easy process. Resize your photos to the pixel dimensions mentioned above (use your program's image-sizing menu), and then sharpen the photo until it looks good on your screen (use your program's sharpening menu).

Small JPEG photos are not big enough to print a good-quality image on an inkjet printer, so they are relatively protected from people wanting to 'borrow' your work for their own purposes.

Emailing photos is as simple as sending them as attachments. Uploading your images to a website requires a little more computer knowledge if you're going to do it all yourself, but there are sites on the Internet that will allow you to upload your images by following a few simple instructions. Take a look at www.kodak.com, for example, which offers a variety of online album options and printing services over the web.

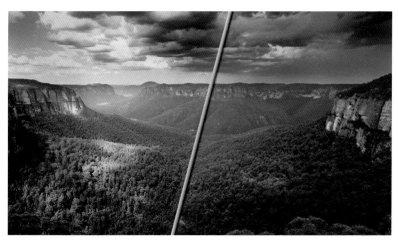

Govett's Leap, Blue Mountains, Australia

The left side of the image is high resolution, while the right-hand side is lower resolution and taken from a large web image. As you can see, while web resolution can look fine on screen, it doesn't look so good when printed, and this means small copies of your photos on the Internet are relatively well protected.

▲ DSLR, 14mm lens, f8, ISO 100, 4072 x 2708, RAW, tripod

AUDIOVISUAL PRESENTATIONS

One of the most powerful ways to show your photographs is as an audiovisual display. This is a series of photographs that dissolve from one into the next with a stirring musical track accompanying them. In the past, the only way to produce an audiovisual presentation was to shoot colour slides (transparencies) and use a multiple projector outfit. It was complicated to set up, difficult to program and you needed a darkened room to view it.

With digital files, you can now produce a digital slide show on your computer. It can be viewed on your television set (with the appropriate cables or by first burning a DVD), or you can use a digital projector.

Producing a digital slide show can be as easy as moving digital files of your photos into a folder on your computer and pressing a button in a slide-show program. These simple programs (such as Kai's PowerShow and CompuPic's ProShow Gold) allow you to set the duration of the image shown on the screen and the time one image takes to dissolve into the next. You can also point the program to a sound file and it will play the music at the same time.

For more control over your presentation, you can use programs such as Microsoft Power-Point, Macromedia Director or Adobe Premiere® to produce a sophisticated slide show with varying time and dissolve durations.

The soundtrack you choose to accompany your photos can enhance the viewing experience. (Be aware of copyright issues with the music you decide to use.)

FURTHER READING

Many of the books that influenced the author are no longer in print, but they may be purchased second-hand from www.amazon.com or www.ebay.com.

Adams, Ansel
Camera and Lens
New York Graphic Society, 1976

Adams, Ansel
The Negative
Bulfinch Presss, 1995

Adams, Ansel
The Print
Bulfinch Press, 1995

Ephraums, Eddie
Creative Elements
Amphoto Books, 1995

I'Anson, Richard
Travel Photography
Lonely Planet Publications, 2004

Jarver, Peter
The Top End of Down Under
Seven Hills Books, 1989

Kenna, Michael
Michael Kenna:
A 20 Year Retrospective
Nazraeli Press, 2003

Nankin, Harry
Range upon Range: The Australian Alps
Algona Publications and
Notogaea Press, 1987

Rowell, Galen
Mountain Light
Sierra Club Books, 1995

Sexton, John
Quiet Light
Bulfinch Press, 1990

Evening, Martin
Adobe Photoshop CS
for Photographers
Focal Press, 2004

USEFUL WEBSITES

Amazon.com
www.amazon.com

Ansel Adams Gallery
www.anseladams.com

Better Digital Magazine
www.betterdigitalonline.com

Better Photography Magazine
www.betterphotography.com

Digital Photography Review
www.dpreview.com

Lonely Planet
www.lonelyplanet.com

Luminous Landscape
www.luminous-landscape.com

National Geographic Society
www.nationalgeographic.com

Rob Galbraith Digital Photography Insights
www.robgalbraith.com

INDEX

bold refers to image captions

NOTES

NOTES